CONTENTS

ACKNOWLEDGMENTS

I wish to thank Columbia College Chicago for granting me release time from teaching. Columbia College also awarded me a monetary faculty development grant. The release time and grant were most valuable in helping me to research, write, and fund a major portion of this book.

I am most grateful to the many institutions that permitted me to use their photographs. A special thank you is extended to the University of Illinois at Chicago Jane Addams Memorial Collection (JAMC), Chicago Public Library, Southeast Historical Society, Illinois Labor History Society, Hispanic Housing Development Corporation, Chicago History Museum, Library of Congress, University of Chicago Library, *La Raza* newspaper, the *Columbia Chronicle*, *In These Times*, Centro de Estudios Puertorriqueños (Hunter College, CUNY), Service Employees International Union, Chicago Workers' Collaborative, Wayne State University, Puerto Rican Cultural Center, Puerto Rican Parade Committee, and Casa Central.

Many individuals permitted me use of insightful photographs from their institutional or personal family collections. I extend a most heartfelt thank you to all of them. Special gratitude is extended to Luis Cabrera, Richard Stromberg, Tomas V. Sanabria, Jaime Rivera, Marixsa Alicea, Leslie Orear, Linn Orear, Ivette Velasquez, Hilda Frontany, Antonio Villalobos, Efrain López, Jorge and Luz Maria Prieto, Delores and Emilio Reyes, and Cesareo and Luz Maria Rivera.

Mike Ogata and Ken Nomura from Triangle Camera did an outstanding job of restoring, cleaning, and enhancing many of the older photographs.

A special thank you to Melissa Basilone, senior acquisitions editor at Arcadia Publishing. I appreciate your helpful suggestions on improving the book and your unwavering faith in the value of this project.

IMAGES
of America

CHICAGO LATINOS
AT WORK

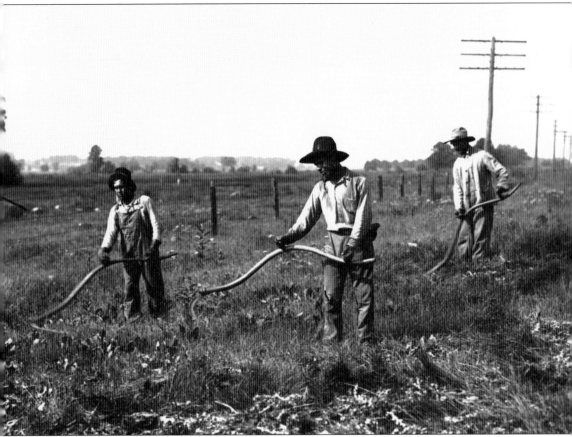

This 1917 photograph is of unidentified Mexican workers in Willow Springs, Illinois. The men are working with scythes to cut weeds along the side of a road. Power lines on tall wooden poles extend in the distance behind the workers. (Courtesy Chicago History Museum.)

ON THE COVER: At the dawn of the 19th century, many Latina women worked in garment factories. Please see page 15. (Courtesy Chicago History Museum.)

IMAGES
of America

CHICAGO LATINOS AT WORK

Wilfredo Cruz

ARCADIA
PUBLISHING

Published by Arcadia Publishing
Charleston SC, Chicago IL, Portsmouth NH, San Francisco CA

Printed in the United States of America

Library of Congress Control Number: 2009934461

For all general information contact Arcadia Publishing at:
Telephone 843-853-2070
Fax 843-853-0044
E-mail sales@arcadiapublishing.com
For customer service and orders:
Toll-Free 1-888-313-2665

Visit us on the Internet at www.arcadiapublishing.com

This book is dedicated to my wife, Irma, and to our children, Wilfredo Jr., Daniel Cesar, and Alexandra Irma. I appreciate the assistance and motivation you provided during the time I worked on this project. And also to all the first-generation Latinos, who worked so hard so their children could have better lives.

INTRODUCTION

Chicago has always been a magnet attracting immigrants. Successive waves of newcomers historically flocked to the city by the lake. At the dawn of the 19th century, hundreds of thousands of Irish, Italians, Germans, Poles, Jews, and other European ethnic groups crossed oceans to come to Chicago. These European ethnic groups worked hard in the city's heavy industries. They worked in the steel mills, packinghouses, stockyards, and factories. They carved out their own distinct ethnic neighborhoods throughout the city. They made good money, and after a few generations, they achieved middle-class status. Many eventually left the city and moved to the suburbs.

Like previous European immigrants, Latinos also came to Chicago seeking a better life for themselves and their children. Yet the story of Latino immigration to Chicago has not been adequately chronicled. Even though Latinos have had a presence in Chicago since the early 1900s, little has been written about their experiences. Chicago is one of a handful of major American cities with a large population of different Latino groups. Latinos are an important part of Chicago's history. The 2000 U.S. Census showed explosive growth in the city's Latino population. For the first time since the 1950 census, Chicago's population increased by 4 percent, due mainly to Latino growth. Latinos in Chicago increased by nearly 210,000 from 1990 to 2000. During the same period, whites in the city decreased by 150,000 and blacks declined by 20,000.

In the coming decades, African Americans and whites in Chicago will continue to decline, while Latinos will continue to grow. Latino growth will come about mainly through births, combined with continued immigration. Since the 2000 U.S. Census, there are now over a million Latinos in Chicago or 29 percent of the city's population. There are another million Latinos in Chicago's surrounding suburbs. Latinos undoubtedly are key players in the city's future. They are helping to shape the character of the city, including its politics, its neighborhoods, and its economy.

The Latino community of Chicago is a rich ethnic tapestry, not a monolithic group. There are obvious immigration, socioeconomic, educational, and political differences among the groups. Some Latinos in Chicago are making great strides. They are progressing and moving up into the economic mainstream. They are college educated and hold white-collar, well-paying jobs. Yet others are making slower progress. Still others are struggling to put food on the table. Some Latinos came to the city when good-paying industrial jobs were plentiful. Others came later, when opportunities in heavy industries dried up. Some Latinos who immigrated to the city were middle-class professionals. Others were poor, uneducated, undocumented, and did not speak English. Some Latinos have lived in Chicago for several generations. Others arrived yesterday.

Traditionally, Mexicans and Puerto Ricans have been the two largest Latino groups in Chicago and the Midwest. Of Chicago's Latino population, Mexicans are about 70.4 percent and Puerto Ricans comprise 15 percent. Together the two groups are about 85 percent of Latinos in Chicago. Thus many of the photographs in this book focus on the work experiences of these two larger groups. Mexicans were the first Latino group to set roots in Chicago and secure a foothold in the city's heavy industries. As early as 1916, a sizable number of Mexicans settled in Chicago.

Puerto Ricans first came to the city in the late 1940s. Their migration to the city peaked during the 1950s and 1960s. Unlike most other Latino groups, Puerto Ricans came as American citizens. Yet they faced many of the same hardships most Latino immigrant groups encounter when coming to a new city. In subsequent decades, other Latino groups like Cubans, Guatemalans, and Salvadorans arrived and called Chicago their home. They too immigrated to Chicago seeking work.

This photographic book is an attempt to put a human face on the Latino worker in Chicago. It shows many of the jobs Latinos held in the past and continue to hold in the present.

One

SEEKING DECENT WORK

The first Latino arrivals to Chicago came principally seeking economic opportunities. They came to work. As mainly poor and working-class laborers, they did not have much capital, education, or skills. But they eagerly took on hard, backbreaking, and often dangerous jobs hoping to earn decent wages. They did not come seeking charity. They came searching for a brighter tomorrow.

The onset of World War I and World War II created severe labor shortages in the United States. Midwestern industries needed a plentiful supply of cheap and unskilled labor. These industries looked to Mexicans and Puerto Ricans to fulfill the need. Companies recruited Latino workers to toil and sweat on the railroads and in the steel mills, meatpacking plants, foundries, stockyards, and factories of the city and its surrounding suburbs. Large companies recruited thousands of Latino workers to pick crops as migrant farmworkers throughout the Midwest.

The first significant group of Latino workers in Chicago were Mexicans, who arrived to work on the railroads. In 1916, Chicago-area railroad companies recruited Mexican workers from the Texas-Mexico border. The number of Mexicans working for Chicago railroad companies rose from 206 in 1916 to over 5,255 in 1926. The railroad companies confined Mexicans to the laborer jobs constructing new railroad lines or maintaining existing ones. Mexicans performed physically strenuous work, often in below-freezing weather. Employers were pleased that Mexicans worked hard and long hours for low wages. By 1928, Mexicans were 11 percent of the workers in 15 of the Chicago area's meatpacking, steel, and other plants.

In 1948, U.S. Steel brought in over 500 Puerto Rican contract workers for its Gary, Indiana, plant. Hundreds of Puerto Ricans labored in the steel mills of South Chicago, Gary, and East Chicago, Indiana. Puerto Ricans worked largely in unskilled occupations in the blast furnaces, where the work was unbearably hot and dangerous. An agency of the Department of Labor of Puerto Rico was established in Chicago in 1949 to help recruit even more Puerto Ricans for work in the city.

Early Latino immigrants often experienced discrimination. They were not welcomed as permanent neighbors or accepted as American citizens. Large companies welcomed Latinos as cheap laborers, but these companies hoped that once they completed their contracts they could return to their homeland. Over the intervening years, many more Mexicans and Puerto Ricans voluntarily immigrated to the city seeking work in industrial plants and factories.

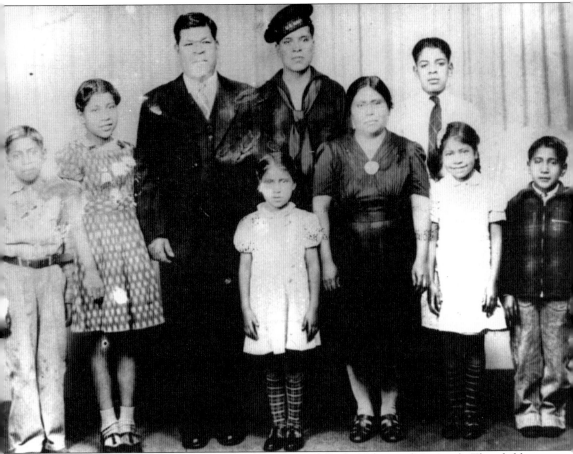

This is a 1942 portrait of the family of Bacilio and Paula Valencia (Mexican). The children are unidentified. They were one of the early families of Mexican descent to settle in the South Deering neighborhood. Bacilio worked on the railroads and later in the steel mills. Their older son (center) joined the U.S. Navy. (Courtesy Southeast Historical Society.)

Beginning around 1916, Mexicans began working for railroad companies in Chicago. Chicago-area railroad companies recruited Mexican workers from the Texas-Mexico border. Companies like Santa Fe, Topeka, and Burlington send labor recruiters to Texas to recruit Mexican laborers. The individual in the photograph is unidentified. (Courtesy Illinois Labor History Society.)

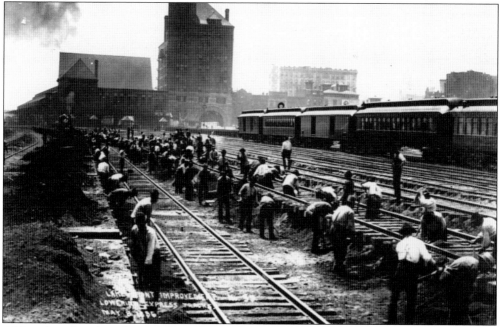

Although railroad work was physically challenging, Mexican workers were up to the task. Mexican railroad workers performed the hard, backbreaking laborer jobs such as constructing new railroad lines—like the men in this photograph, who are constructing railroad lines in Chicago's Grant Park in the early 1920s. (Courtesy Illinois Labor History Society.)

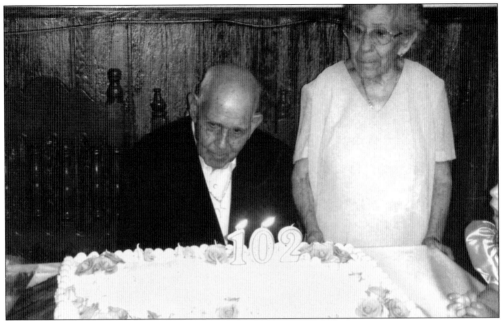

Felipe Valdez (Mexican) celebrated his 102nd birthday in 2009. His wife, Rebecca, 94, looks on. The couple has been married for 78 years and has 11 sons and 3 daughters. Felipe worked for a Chicago railroad company from 1927 to 1929. However, due to the Great Depression, Felipe and many other Mexican workers were laid off from their jobs. He, and other Mexican workers, returned to Mexico. In Mexico, Felipe ran a small grocery store for many years. He eventually returned to Chicago. (Courtesy Oscar Valdez.)

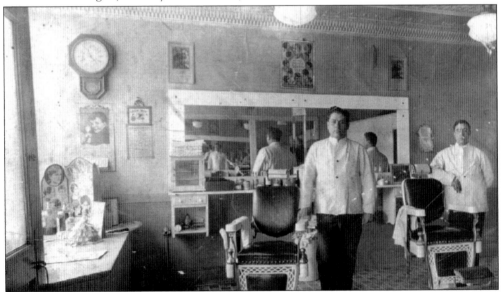

Some Mexicans opened small businesses like pool halls, taverns, restaurants, bakeries, and barbershops to cater to the growing Mexican community of South Chicago and South Deering during the early 1930s. Owner Nicolas Garcia (Mexican, foreground) is inside his Nuevo Mundo barbershop at Ninetieth and Brandon Streets in the early 1930s. At his side is his brother Juan. (Courtesy Dolores and Emilio Reyes.)

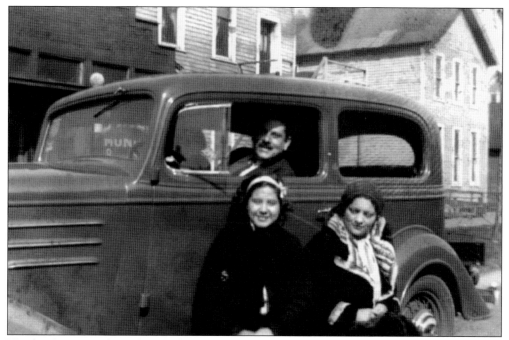

Nicolas Garcia, with unidentified relatives, is pictured in front of his Nuevo Mundo barbershop in the early 1930s. Despite limited English, Garcia passed the state license to become a barber. (Courtesy Dolores and Emilio Reyes.)

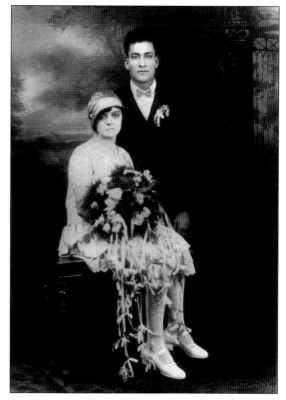

Justino Cordero (Mexican) was a respected business and community leader in South Chicago. In 1926, Cordero married Caroline Kon, who was Polish. Marriages between unrelated nationality groups were rare before World War II. They were married in the original frame mission church of Our Lady of Guadalupe. (Courtesy Southeast Historical Society.)

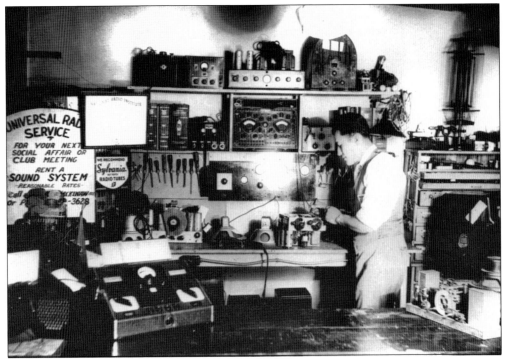

Justino Cordero, a business owner, is in his radio shop at 3315 East Eighty-ninth Street in 1943. (Courtesy Southeast Historical Society.)

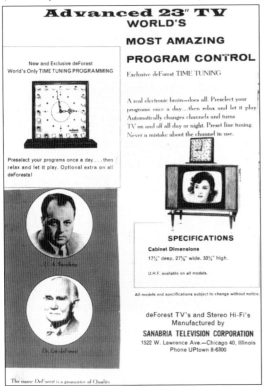

One early Puerto Rican to settle in Chicago was Ulises Marcial Sanabria, who came to study medicine at Rush Medical College in Chicago in 1901. He was a renowned concert pianist. He married in Chicago and had four children. Sanabria died of a heart attack at age 46. His son Ulises Armand, shown here in the early 1950s, became a famous inventor in the field of television. His numerous inventions helped perfect the modern television. In 1931, he founded the Sanabria Television Corporation in Chicago. (Courtesy Antonio Irizarry.)

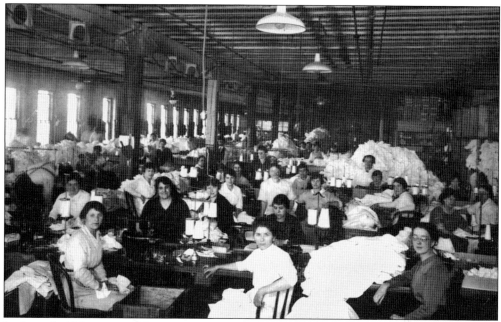

In the early 19th century, Mexican women worked as garment workers in sweatshops in Chicago. The Mexican women often worked long hours in poorly ventilated workplaces alongside European women garment workers like those pictured here at their machines. The women were working for the White Goods Company in the early 1920s. (Courtesy Chicago History Museum.)

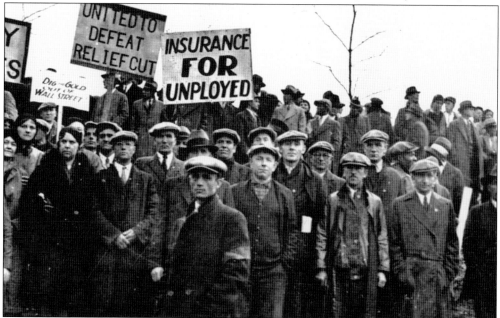

Due to prejudice, some settlement houses and charities refused to extend food or relief to unemployed Mexican families during the Great Depression. One settlement house that consistently did help Mexicans was the University of Chicago settlement house founded by Mary McDowell. This was a hunger march organized by the settlement house in 1932. Mexicans surely participated in the march. (Courtesy University of Chicago Library.)

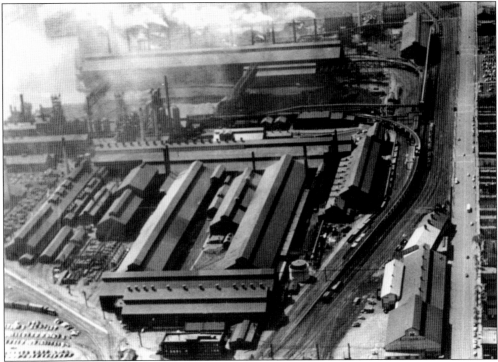

In the early 1920s, many Mexicans began working in the steel mills. Later, in the 1950s, hundreds of Puerto Ricans joined Mexicans in the steel mills of South Chicago, Gary, Hammond, and East Chicago, Indiana. Pictured here is Wisconsin Steel in 1948 in the South Deering neighborhood. In the 1980s and 1990s, most of the mills in the area, including Wisconsin Steel, shut down. Thousands of steelworkers were thrown onto the unemployment lines. (Courtesy Southeast Historical Society.)

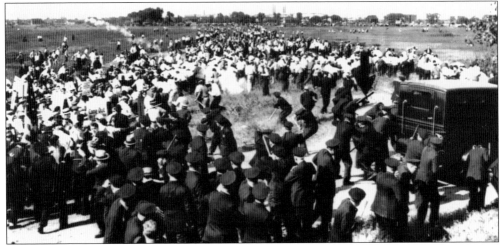

A tragic and infamous event in Chicago labor history was the Memorial Day Massacre of 1937. The U.S. Steel Corporation agreed to a union contract. However, Republic and Inland Steel would not agree. Instead, Republic Steel hired nonunion workers. Thus a large rally, including many Mexican steelworkers, was held by the union in a large field in South Chicago where police began shooting at the peaceful protestors. (Courtesy Illinois Labor History Society.)

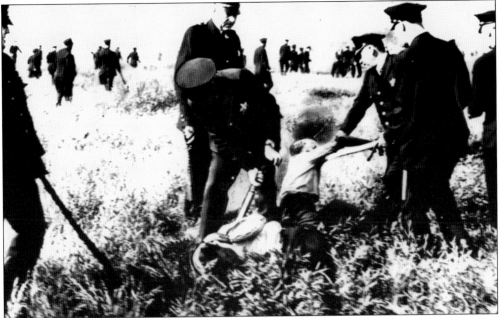

More than 200 police rushed the crowd and began violently beating the protestors with clubs. There were 10 unionists killed from gunshot wounds to the back and side. Another 125 marchers were seriously injured by police. (Courtesy Illinois Labor History Society.)

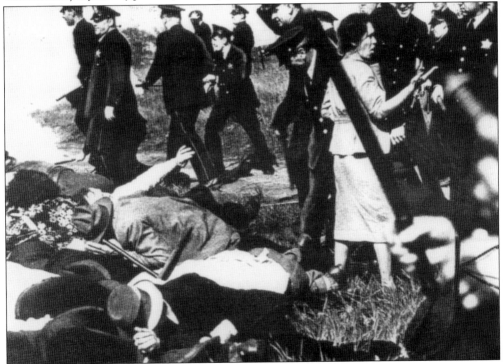

Lupe Marshall (Mexican), pictured here, was a social worker from the Hull House settlement. She was at the rally as an observer. Marshall was pleading with the police to stop the brutality. (Courtesy Illinois Labor History Society.)

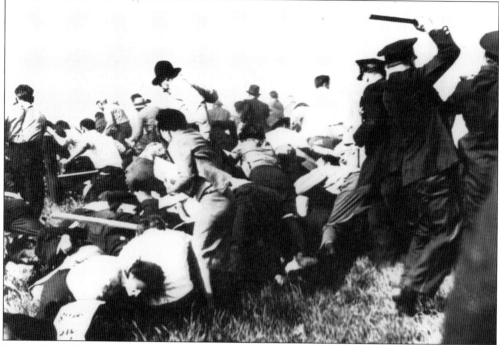

Lupe Marshall was violently pushed to the ground by police. She was dragged and thrown into a paddy wagon with other seriously injured victims. The LaFollette Commission was formed in 1937 to investigate the riot. Lupe Marshall testified at the commission about the police violence she saw. The commission concluded that the police used excessive violence and were not provoked by the protestors. (Courtesy Illinois Labor History Society.)

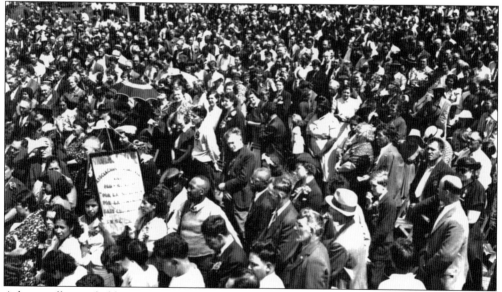

A large rally was held in 1939 to commemorate the victims of the Memorial Day Massacre of 1937. Many labor groups, union members, and friends from throughout the Calumet region were in attendance. Pictured on the left is a group of Mexican women under their banner showing their support for the injured and fallen workers. (Courtesy Chicago History Museum.)

Mexicans and Puerto Ricans in the steel mills worked largely as unskilled laborers in the blast furnaces like the one pictured here. Such work was of lower pay and hot and dangerous. The individual here is unidentified. In the 1960s, Mexicans and Puerto Ricans sued the steel companies and their own union for discriminatory practices. As a result, some Latinos were promoted into better-paying, skilled jobs. (Courtesy Illinois Labor History Society.)

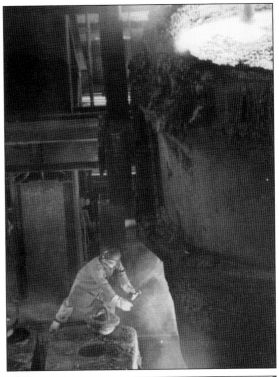

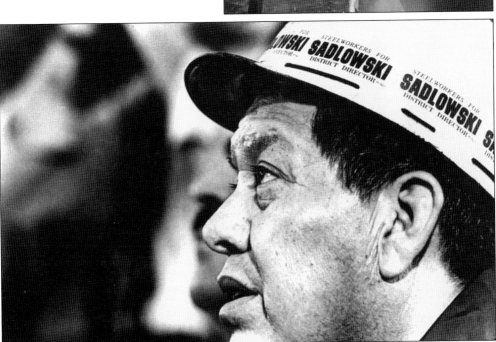

Mexican and Puerto Rican steelworkers were very involved in labor activism. They demanded higher pay and promotions. They were active in their union, the United Steel Workers of America (USWA). Here an unidentified Mexican steelworker wears a hard hat supporting fellow worker Ed Sadlowski, who is running for office in the USWA in the early 1950s. (Courtesy Southeast Historical Society.)

Many Mexicans and Puerto Ricans worked in foundries like the one pictured here. In the foundries, the steel was melted and molded into various sizes. Some foundries were part of the steel mills, and others were independent businesses. The individuals here are unidentified. (Courtesy Illinois Labor History Society.)

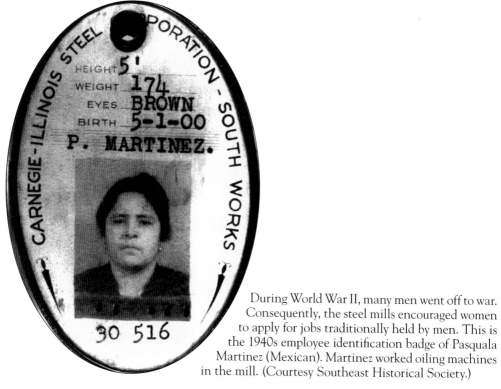

During World War II, many men went off to war. Consequently, the steel mills encouraged women to apply for jobs traditionally held by men. This is the 1940s employee identification badge of Pasquala Martinez (Mexican). Martinez worked oiling machines in the mill. (Courtesy Southeast Historical Society.)

The wedding of Cesareo and Luz Maria Rivera (Puerto Rican) took place at Our Lady of Guadalupe Church in South Chicago in 1952. Cesareo came to Chicago in 1951 from Caguas, Puerto Rico. He worked in the steel mills of Indiana and later in Chicago factories. For many years, he also ran a small grocery store in the Englewood neighborhood, where they currently live. (Courtesy Cesareo and Luz Maria Rivera.)

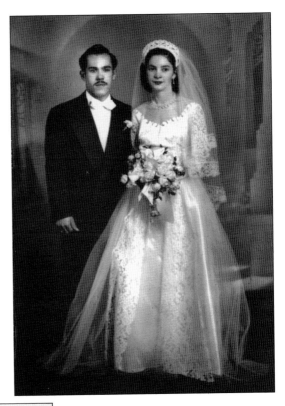

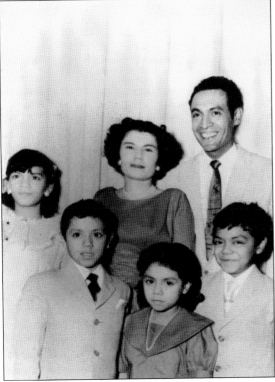

Eduardo Ortiz (Puerto Rican) migrated to Chicago in 1953 from Puerto Rico. He worked for over 30 years in the steel mills of South Chicago. He is shown here with his family in 1958. Pictured from left to right are (first row) Pablo, Providencia, and Wilfredo; (second row) Elisa, wife Maria, and Eduardo. Eduardo's son, Wilfredo, became a high school principal with the Chicago Public Schools. (Courtesy Wilfredo Ortiz.)

21

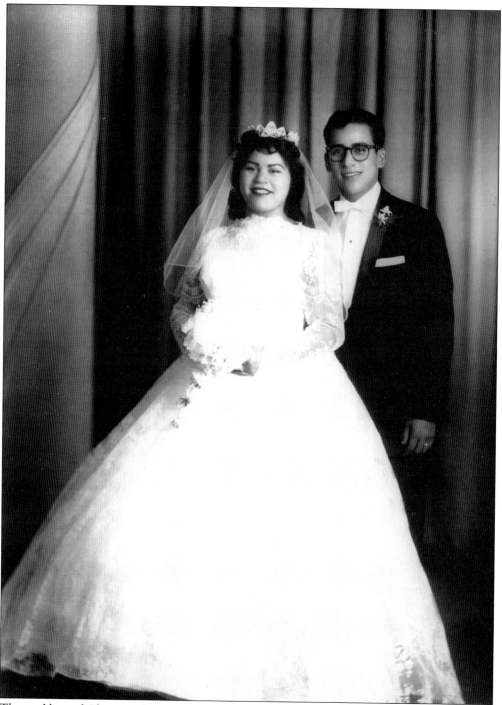

The wedding of Abram and Rosa Jacinto (Mexican) was in 1960. Abram worked for 21 years at Wisconsin Steel Works until the mill unexpectedly shut down in 1980. More than 3,500 steelworkers lost their jobs. Many Wisconsin Steel workers were not paid millions of dollars in earned vacations, salaries, and pensions. Abram and Rosa now work in small factories in Chicago. (Courtesy Abram and Rosa Jacinto.)

Manuel and Ana Alicea (Puerto Rican) are seen on their wedding day in 1953 in Hammond, Indiana. The other relatives are unidentified. Manuel worked in the steel mills of Indiana for many years. He came to Chicago and worked for over 30 years as a janitor. Ana worked in small factories. They have one son and two daughters. In 2003, they celebrated their 50th wedding anniversary. (Courtesy Marixsa Alicea.)

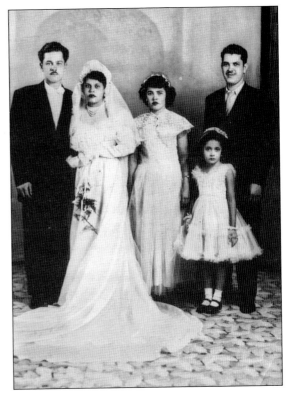

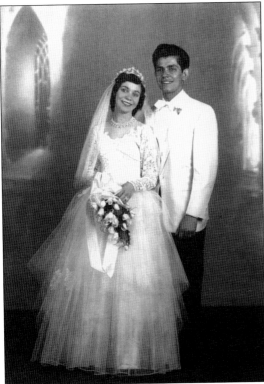

Gilberto and Martha Hernandez (Puerto Rican) both came from Puerto Rico to Chicago in 1952. They met in Chicago and married in 1954 at St. Francis of Assisi Church. Gilberto worked for the steel mills in Indiana and later drove his own taxi in Chicago. Martha worked in factories. The couple had two sons and five daughters. Gilberto passed away in 1981. (Courtesy Martha Hernandez.)

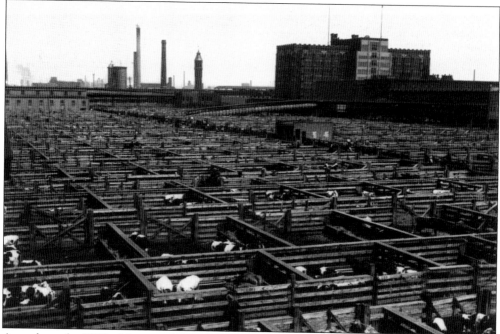

As early as the 1920s, Mexicans began working in the Union Stock Yard, pictured here in the 1940s. In the 1950s, many Puerto Ricans also worked in the stockyards. The Union Stock Yard was located in the Back of the Yards neighborhood, where many Mexicans lived. Latinos worked mostly as laborers in the packinghouse freezers and on the killing floor butchering livestock. (Courtesy Chicago History Museum.)

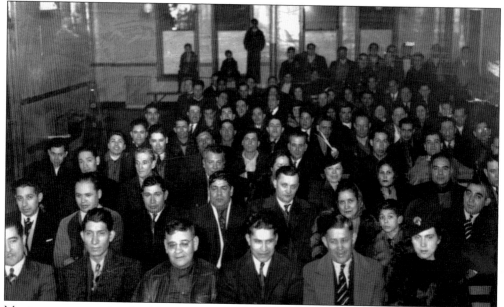

Mexicans were very involved in unions and labor activism in the meatpacking industry. This is a meeting of the Mexican United Packinghouse Workers in Chicago around 1938. The thriving meatpacking industry was a major supplier of jobs for Mexican immigrants. (Courtesy Chicago History Museum.)

24

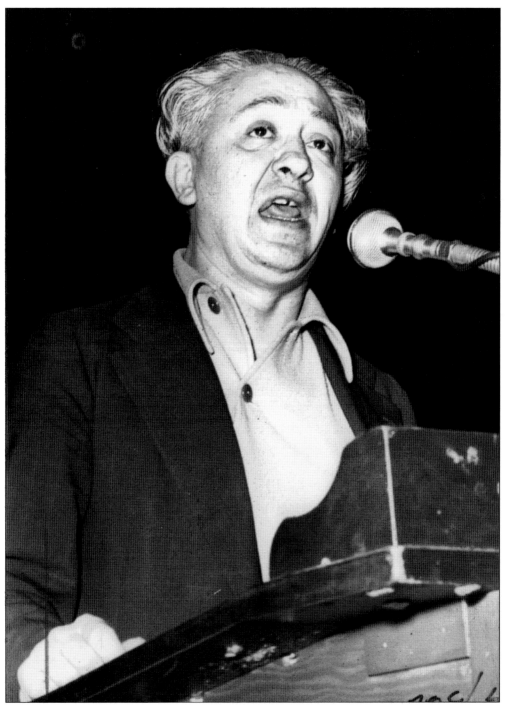

Refugio Martinez (Mexican) was a prominent labor organizer of the United Packinghouse Workers of America during the 1930s in Chicago. He actively organized Mexican meatpacking workers at the Swift Company. In the late 1930s, he was deported back to Mexico by the U.S. federal government because of his alleged ties to the Communist Party. (Courtesy Illinois Labor History Society.)

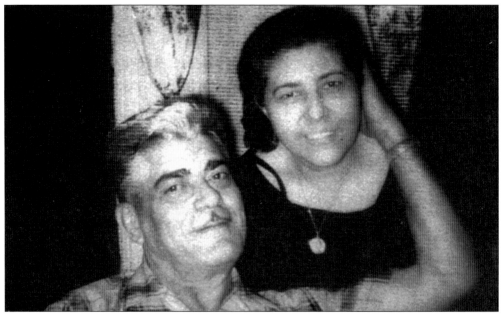

Leonor and wife Blanca Diaz (Puerto Rican) are pictured in 1966. Leonor came from Puerto Rico as a contracted farmworker to pick crops in Florida in 1949. He came to Chicago in 1950 and worked butchering livestock in the Union Stock Yard. He also worked as a janitor for many years. Blanca worked washing dishes and clothes in hotels. They raised three sons and a daughter. All three sons joined the U.S. military. See page 78. (Courtesy Hilda Frontany.)

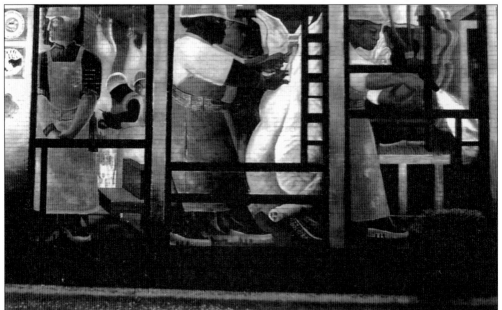

In 1974, William Walker painted his famous mural *The History of The Packinghouse Worker.* The right side of the mural (pictured here) shows African American, white, and Latino workers going about their slaughterhouse jobs with pride. The left side shows workers confronting bosses, demanding a union contract. It is one of a few murals in Chicago dedicated to workers. (Photograph by Wilfredo Cruz.)

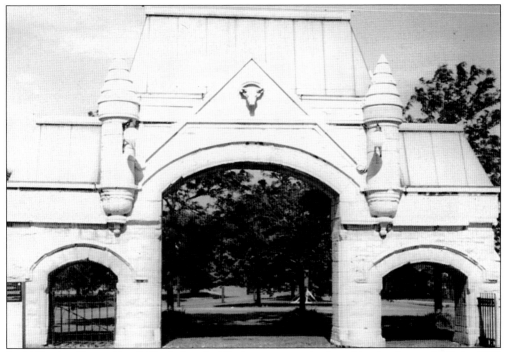

In 1971, the Union Stock Yard closed. All that remains is the white brick gate built in 1875 with the head of a steer in the middle. This is the gate thousands of cattle passed through each day. Thousands of workers also came through this gate each day to work. (Photograph by Wilfredo Cruz.)

During the Great Depression, many Mexicans were unemployed. Therefore Mexicans joined Jewish and other European vendors and sold fruit, clothes, handicrafts, shoes, and furniture in the outdoor market known as Maxwell Street in the Hull House neighborhood. This is a view of immigrant vendors on Maxwell Street in the 1930s. (Courtesy University of Illinois at Chicago JAMC.)

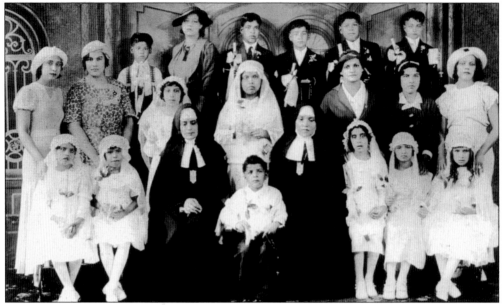

Some Mexican women dedicated their lives to working for the Roman Catholic Church. The Cordi-Marian Sisters Missionary Congregation was exiled from Mexico in 1927. They came to Chicago to work with Mexican immigrants. Here Cordi-Marian sisters are pictured with Mexican children doing their holy communion in 1935 at Our Lady of Guadalupe Church. (Courtesy Southeast Historical Society.)

Social reformers Jane Addams and Ellen Gates Starr founded the Hull House settlement house in 1889. The settlement house helped many generations of immigrants. These Mexican young men learned automobile skills in a workshop at Hull House in 1959. Pictured from left to right are Lee Gonzalez, unidentified, and Jimmy Aguilar. (Courtesy University of Illinois at Chicago JAMC.)

Many early Mexican immigrants to Chicago quickly realized that to get ahead in the workforce they had to master the English language. In the evening after work, many Mexicans enlisted in English classes at Hull House. This is an English class at Hull House in 1945. (Courtesy University of Illinois at Chicago JAMC.)

Faustino Lopez (Mexican) was hoping to get ahead in the workforce by learning English. He attended an English class at Hull House in 1945. (Courtesy University of Illinois at Chicago JAMC.)

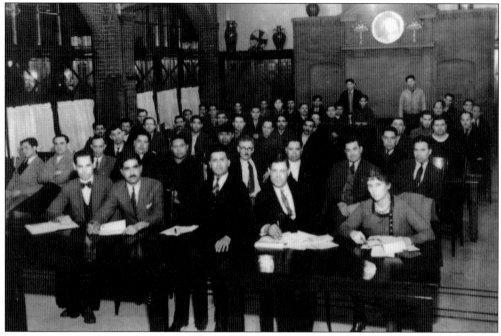

Mexicans realized that to progress in the workforce and in the United States they had to become American citizens. This is a citizenship and naturalization class, attended by Mexicans at Hull House in 1940. (Courtesy University of Illinois at Chicago JAMC.)

This is a citizenship and naturalization class attended by Mexicans at Hull House in 1960. (Courtesy University of Illinois at Chicago JAMC.)

Many Mexican families in the Hull House neighborhood in the 1920s lived around Taylor and Halsted Streets. They lived in overcrowded apartment buildings like the one pictured here. Outbreaks of tuberculosis were common. (Courtesy University of Illinois at Chicago JAMC.)

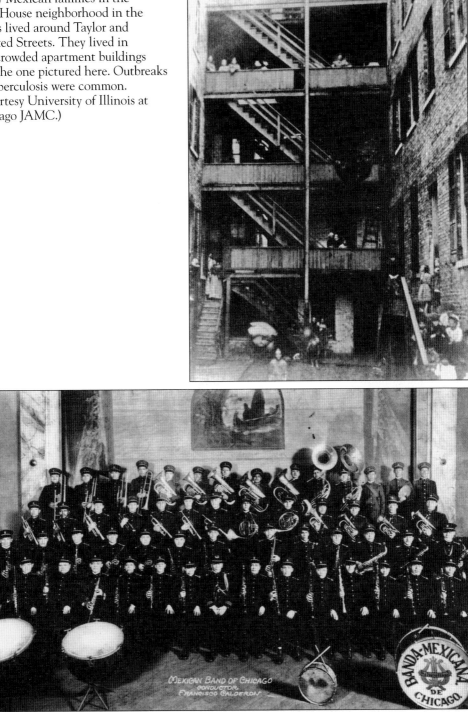

Some Mexican men supplemented their income by playing in musical bands. This is the Mexican band of Chicago in 1928. The band played throughout Chicago. They practiced their music at the Hull House settlement. (Courtesy Tomas V. Sanabria.)

Many early families who came to Chicago from Mexico and Texas were migrant farmworkers. Jaime and Minerva Guzman (Mexican) were farmworkers for over 20 years. They would come from Texas to harvest crops in Illinois, Michigan, Wisconsin, Florida, and Montana. They eventually gave up migrant work. They arrived in Chicago in 1966 and worked for many years in small factories. (Courtesy Irma Cruz.)

Mexican children are seen here in a migrant labor camp in Jackson, Michigan, in 1947. The Mexican families, called *braceros* or "helping arms," came mainly from Mexico and Texas to pick tomatoes and onions. The Salvation Army visited the camps once a month and gave the children food and clothes. The children worked alongside their parents in the fields. The families stayed in barracks like the one pictured in the background. (Courtesy Teresa Ramos.)

Frank and Jovita Duran (Mexican) are at a fancy nightclub in Chicago in 1946. The Durans' parents both worked for the railroads in Chicago in the early 1920s. The Durans lived in the Hull House neighborhood. Frank Duran drove a taxi for several years. He then ran a tavern for 15 years and worked as a pipe foreman for 12 years for the City of Chicago. Jovita was a homemaker. (Courtesy Frank and Jovita Duran.)

Many young Latino men joined the different branches of the United States military hoping to acquire training and education that would later help them find good-paying jobs in civilian life. Pictured here is Reuben Gonzales (Mexican) at the Great Lakes Naval Training Center in Illinois in 1941. (Courtesy Chicago Public Library, Special Collections and Preservation Division.)

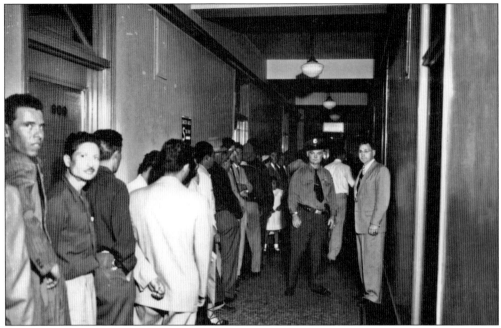

One constant problem for some Mexican workers in Chicago is their lack of American citizenship. Here apprehended undocumented Mexican workers and their families are on the ninth floor of the Chicago Post Office awaiting deportation back to Mexico in 1954. Walter A. Sahli, district immigration officer, stands at the right with detention officer Carl. S. Preston. (Courtesy Chicago History Museum.)

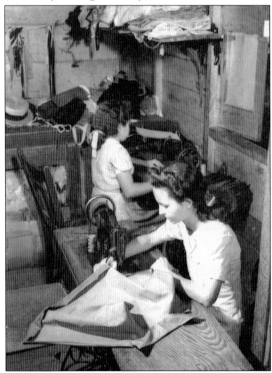

Many women and young girls in Puerto Rico did needlework in small workshops like the one pictured here in Bayamon, Puerto Rico, in 1941. Later, in the 1950s, many of these young women would come to large cities like New York, Philadelphia, and Chicago to work long hours in sweatshops. (Courtesy Library of Congress, Farm Security Administration–Office of War Information [FSA-OWI] Collection.)

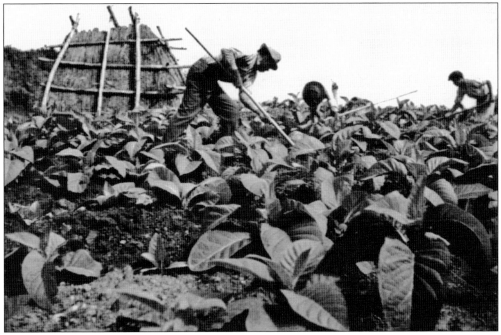

Men in Puerto Rico, like those pictured here in 1938, worked long, grueling hours in tobacco fields. The straw shed in the background is a hurricane shelter. In the late 1940s and early 1950s, many of these men would leave low-paying tobacco work and immigrate to New York and Chicago seeking better-paying industrial jobs. (Courtesy Library of Congress, FSA-OWI Collection.)

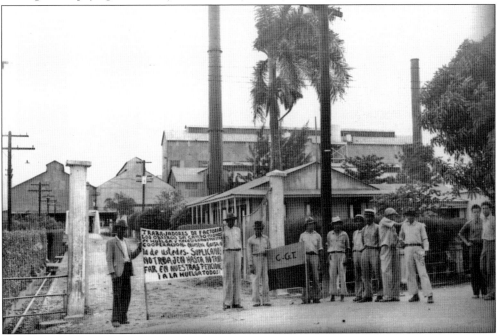

Puerto Ricans have a long history of labor activism. Pictured here are sugar workers on strike at a large American-owned mill in Yabucoa, Puerto Rico, in 1941. The workers were seeking higher wages and better working conditions. (Courtesy Library of Congress, FSA-OWI Collection.)

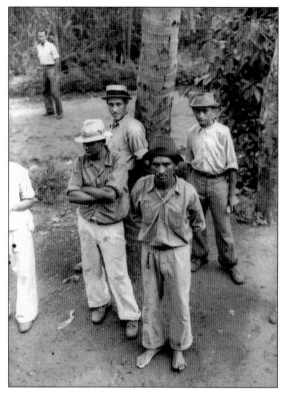

Puerto Rican sugar workers are on strike at an American-owned mill in Yabucoa, Puerto Rico, in 1941. Some of the men could not afford to buy shoes. Due to unemployment and low wages, many of these men eventually left Puerto Rico and came to the United States in search of work. (Courtesy Library of Congress, FSA-OWI Collection.)

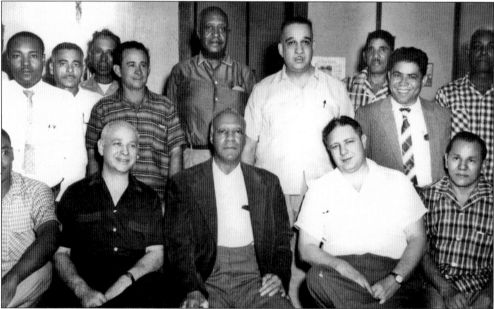

Labor unions from Chicago helped Puerto Rican sugar workers in their attempts to win higher wages. Pictured in Puerto Rico in the early 1950s, local sugar workers of Puerto Rico meet noted labor leaders from Chicago. Pictured in the center of first row is A. Philip Randolph, president, Brotherhood of Sleeping Car Porters (BSCP), and behind Randolph is Milton P. Webster, vice president, BSCP. (Courtesy Illinois Labor History Society.)

Puerto Rican sugar workers are attending a 1956 national convention in Chicago of the United Packinghouse Food and Allied Workers of America. This Chicago union helped Puerto Rican sugar workers in their efforts to win higher wages in Puerto Rico. (Courtesy Illinois Labor History Society.)

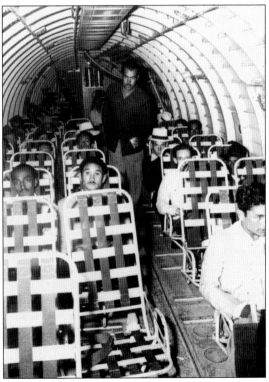

Some of the first Puerto Rican workers in the United States were contracted farm workers. This is a chartered flight of Puerto Rican migrant farmworkers in 1946. Beach chairs are stacked in windowless, decommissioned military planes. The planes would take farmworkers from San Juan to various U.S. cities. Many of the workers eventually left low-paying farmwork for industrial jobs in cities like Chicago. (Courtesy Centro de Estudios Puertorriqueños, Hunter College, CUNY.)

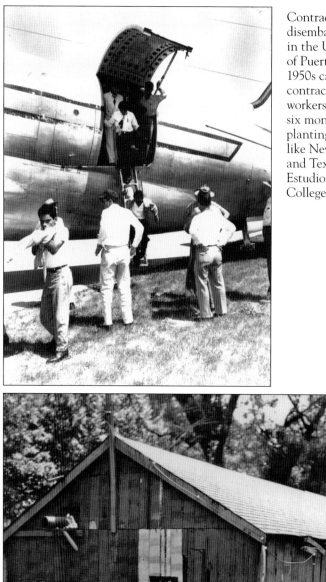

Contracted Puerto Rican farmworkers disembark from a plane in 1946 in the United Sates. Thousands of Puerto Ricans in the 1940s and 1950s came to the United States as contracted farmworkers. Many of the workers were contracted to work for six months to a year. They worked planting and harvesting crops in states like New York, Florida, California, and Texas. (Courtesy Centro de Estudios Puertorriqueños, Hunter College, CUNY.)

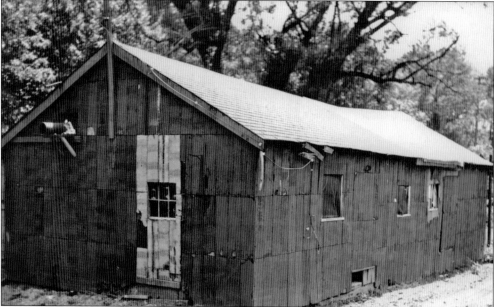

This was a typical barrack for contracted Puerto Rican farmworkers in the United States in 1946. The barracks were often dilapidated and lacked indoor plumbing. Workers complained about their living conditions. The barracks were also isolated away from major cities. Many workers left the camps and searched for better work in the large cities. (Courtesy Centro de Estudios Puertorriqueños, Hunter College, CUNY.)

Eligio Quiñones and his mother, Fundadora, are seen in California in 1960. Quiñones was a contracted farmworker. He worked in New York and California harvesting crops. Quiñones then came to Chicago in 1967 and worked for many years cleaning kitchens and preparing food for American Airlines. (Courtesy Eligio Quiñones.)

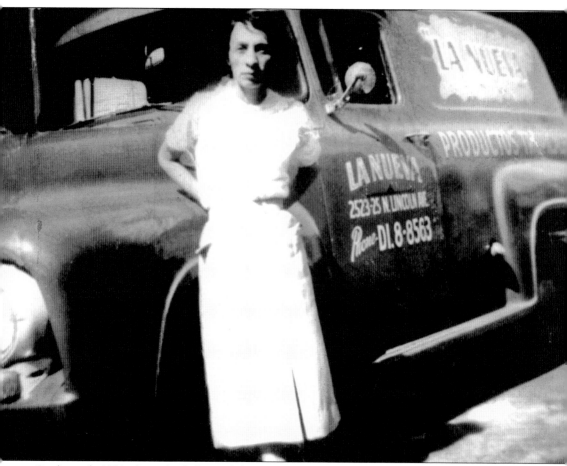

In the early 1950s, large food chains did not carry Puerto Rican food products. A Puerto Rican family owned La Nueva, a small grocery store in Lincoln Park. The small store offered credit to struggling families. The store owner delivered Puerto Rican food products to customers. The unidentified woman is the wife of the owner. (Courtesy Tomas V. Sanabria.)

Two

THE LATER YEARS OF WORK

As more Mexicans and Puerto Ricans arrived in the city during the 1950s and 1960s, they too dreamed of landing steady, good-paying jobs in the city's steel mills and industrial plants. However, by the mid-1950s, steel mills and other heavy industries were significantly cutting back on their labor force. Like most older American cities, Chicago was losing thousands of manufacturing jobs yearly.

A good number of Mexican and Puerto Rican arrivals came to the city uneducated and without knowing English. They found mainly low-paying, menial service jobs. They found employment on the factory assembly lines, as janitors, and as hotel and restaurant workers. They toiled in the hot foundries and worked in suburban factories making things like pipelines. Latina women worked in sweatshops and in factories as assemblers, laundry and dry cleaning operatives, and packers and wrappers.

In the 1960s, 1970s, and 1980s, Cubans arrived and called Chicago their home. Between 1959 and 1980, an estimated 20,000 Cuban refugees arrived in the Chicago area. The first wave was middle- and upper-class educated professionals. Many brought professional skills and investment capital. They were granted political refugee status. With generous financial aid from the U.S. government, many of these immigrants were offered affordable housing, job training programs, and college scholarships.

Additionally, immigrants from South and Central Americans countries like Ecuador, Hondurans, Venezuela, Nicaragua, Guatemala, and El Salvador immigrated to Chicago and its surrounding suburbs during the 1970s and 1980s. Civil strife, bad economies, poverty, and natural disasters in their homelands triggered a sizable exodus of immigrants from these South and Central American countries.

Since the United States denied South and Central Americans political refugee status, many entered the United States illegally. Their undocumented status, lack of formal education, and lack of English were obstacles to finding good-paying jobs. Some women worked as domestic workers, as nannies and maids. Some worked as temporary day laborers earning minimum wages.

Even though the work Latinos took on was physically demanding, and they worked long hours or even two jobs, Latinos endured. What many of these first-generation Latino workers lacked in skills, they made up through their hard work, determination, and perseverance.

Latinos were not docile workers. Through the years, they participated in strikes and demonstrations in various industries. Latinos protested for higher wages, benefits, and improved working conditions. They actively joined trade unions. Some became labor organizers.

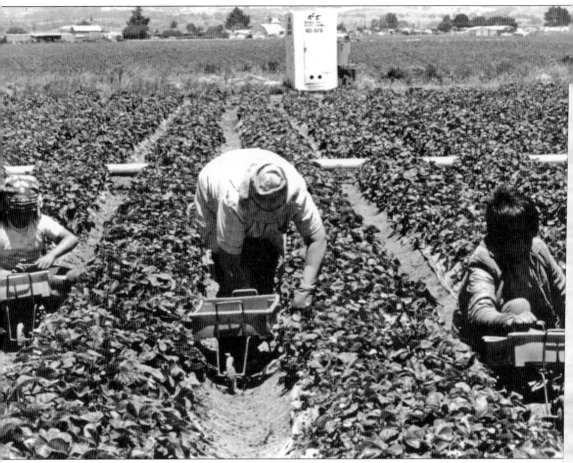

In the 1970s and 1980s, many Mexican families from Texas were still migrant workers. They would come from Texas to plant and harvest crops in Illinois, Michigan, Wisconsin, and Florida. This Mexican family, including the children, worked picking strawberries in 1970. The location is unknown. (Courtesy Wayne State University Library.)

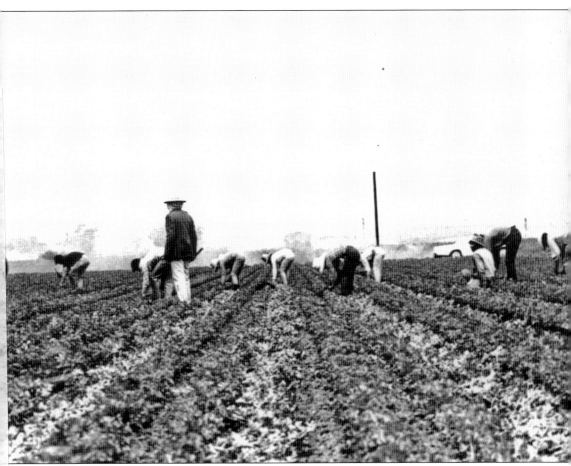

Mexican men are pictured harvesting crops in 1970. The location is unknown. Migrants worked long hours in the hot fields for little pay. The work was very hard, and later many of the men developed back problems. (Courtesy Wayne State University Library.)

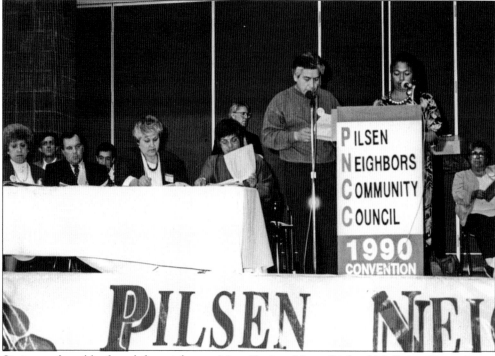

Sitting at the table, from left to right, are Mary Koeing, Mayor Richard M. Daley, Teresa Fraga, and Carmen Velasquez in 1990. Fraga (Mexican) was a migrant farmworker for many years. Fraga and her family came to Chicago in 1966. Fraga later became college educated and a well-known community activist with the Pilsen Neighbors Community Council. (Courtesy Teresa Fraga.)

Dr. Hugo Muriel (Bolivian) was the Chicago Department of Health commissioner under Mayor Jane M. Byrne in 1979. He is one of many emigrants from South and Central American countries who came to Chicago seeking better economic opportunities. (Courtesy Richard Stromberg.)

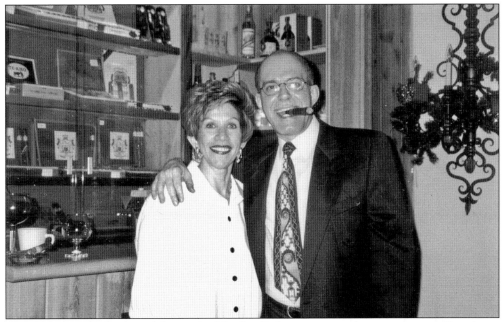

Elias Sanchez (Cuban) and his wife, Martha DeJesus, are in their restaurant, Tania's on Milwaukee Avenue, in 1997. Sanchez escaped from Cuba in 1969. Tania's, in Logan Square, was the best-known Cuban bar, dance hall, and restaurant in Chicago. But after 23 years of service, the restaurant closed in 1998. Sanchez is now a housing developer. (Courtesy Elias Sanchez.)

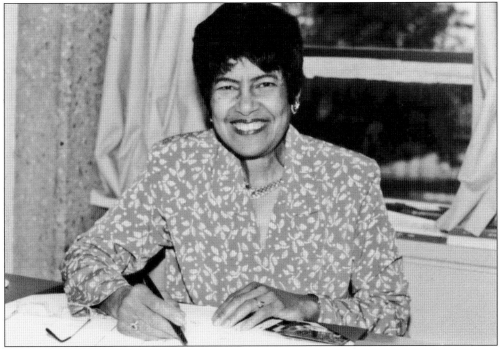

Angelina Pedroso (Cuban) has been a popular professor of Spanish at Northeastern Illinois University for over 44 years. She is pictured here in 1998. Her great-grandparents were slaves in Cuba. (Photograph by Wilfredo Cruz.)

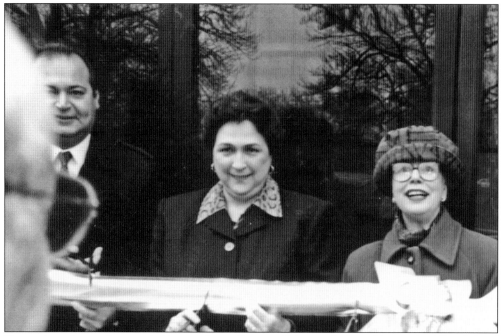

Pictured are former first ward alderman Jesse Granato (Mexican), Ann Alvarez (middle, Cuban/Puerto Rican), and Pastora San Juan Cafferty (Cuban). Alvarez is president of Casa Central, the largest Latino social service agency in Chicago. Cafferty is a longtime professor of social services at the University of Chicago. They participated in a 1997 ribbon-cutting for Casa Central's new $4-million community services center. (Courtesy Ann Alvarez.)

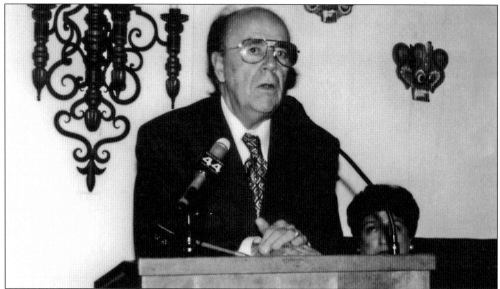

Rev. Daniel Alvarez (Cuban/Puerto Rican) worked for many years providing social services to Chicago's Cuban and Puerto Rican community. He is shown here in 1999. His wife, Ann, is seated on the right. Daniel Alvarez served for many years as president of Casa Central. He was also the former commissioner of the Department of Human Services for the City of Chicago. (Courtesy Casa Central.)

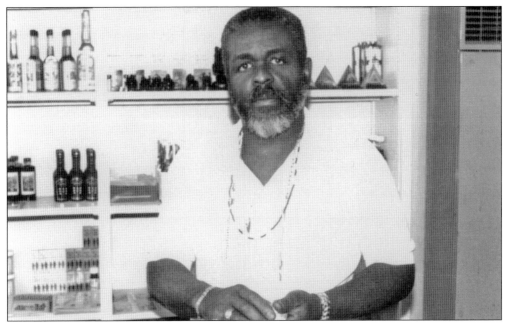

Luis Carlos (Cuban) is in his small store, Botanica Siete Rayos, in the Logan Square neighborhood in 1999. The Botanica sells herbs, teas, plants, oils, lotions, candles, soaps, and perfumes for spiritual cleaning. Carlos believes in the religious faiths of Palo and Santeria. (Photograph by Wilfredo Cruz.)

In 1980, about 2,000 poor Cubans from the port of Mariel, Cuba, were resettled in Chicago. The exiles were dubbed *marielitos*. Churches and social service agencies helped the Cubans find housing and jobs. Here, in 1980, an agency in Humboldt Park provides clothing for the Cuban exiles. (Photograph by Meg Gerken, courtesy *In These Times*.)

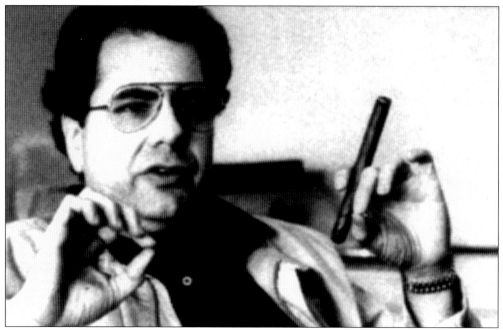

Some Cubans prospered in Chicago by providing services targeted specifically for Latinos. Marcelino Miyares (Cuban), pictured here in the early 1980s, started WBBS-TV (Channel 60), Chicago's first Latino-owned television station. Miyares eventually relocated to Miami, Florida. (Courtesy Richard Stromberg.)

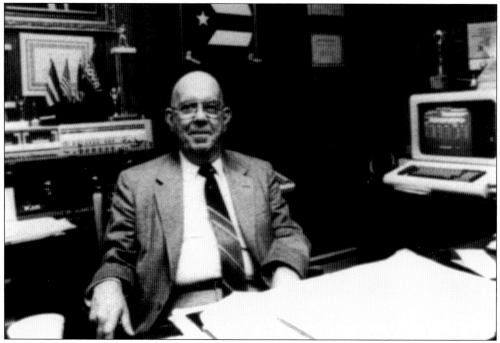

Roberto Perez (Cuban) was regional manager for Goya Products, a large food manufacturer that caters its products to Latinos. He is shown here in the early 1980s. He was also president of the local Cuban American Chamber of Commerce. (Courtesy Richard Stromberg.)

The office of the Cuban American Chamber of Commerce (CACC) on Chicago's north side is seen here. A good number of Cubans are self-employed. There are about 200 Cuban-owned businesses that are members of the CACC. Many of the small businesses are located in the Logan Square neighborhood. (Photograph by Wilfredo Cruz.)

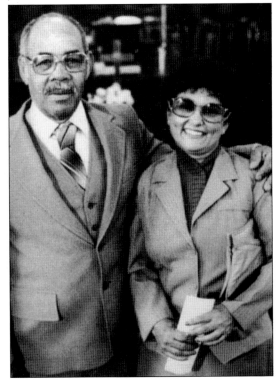

Armando and Luz Delia (Cuban) were farmers in Cuba. Like many Cubans who arrived in the late 1960s, they found work in small factories in Chicago and its surrounding suburbs. They are pictured here in the early 1980s. (Courtesy Richard Stromberg.)

49

Maria Cardenas (Cuban) works with Latino children as a social worker. She works at the Primera Iglesia Hispana Unica de Cristo (First Hispanic United Church of Christ) in Logan Square. She is shown here in 2000. (Photograph by Wilfredo Cruz.)

Achy Obejas (Cuban) is pictured here in 1996. Obejas was a reporter with the *Chicago Reporter*. As an award-winning journalist, she worked for more than 10 years for the *Chicago Tribune*, writing and reporting on cultural events in the city. She later became a well-known author of fiction and poetry. (Courtesy Cleis Press.)

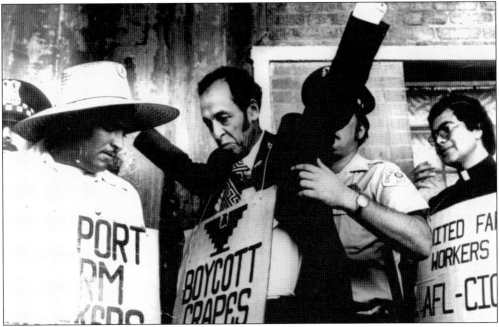

When large California winegrowers refused to recognize their union, Cesar Chavez and the United Farm Workers called for a nationwide boycott of grapes. Dr. Jorge Prieto (Mexican), here with arms raised, supported the boycott and was arrested in 1973 for marching in front of Chicago's South Water Market. Dr. Prieto was one of the first Latino doctors to practice in Chicago. (Courtesy Jorge and Luz Maria Prieto.)

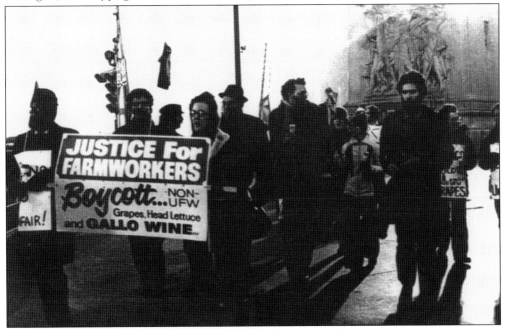

Latinos and their supporters participated in an evening candlelight march along Chicago's Michigan Avenue in the early 1970s. They were marching in support of Mexican farmworkers in California. (Courtesy Wayne State University Library.)

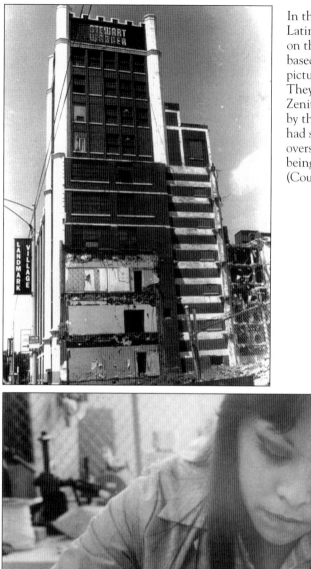

In the 1960s and 1970s, thousands of Latinos, especially women, worked on the assembly lines of large, city-based factories like Steward Warner, pictured here, which made car parts. They also worked at factories like Zenith, Playskool, and Schwinn. But by the 1980s, most of the factories had shut down or moved their plants oversees. Here Steward Warner is being demolished in the early 1990s. (Courtesy Conrad Sulzer Library.)

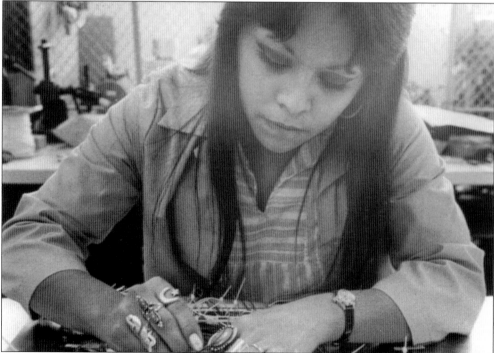

An unidentified Latina woman works on the assembly line of an electronics factory in the early 1970s. The name of the factory is unknown. (Courtesy Illinois Labor History Society.)

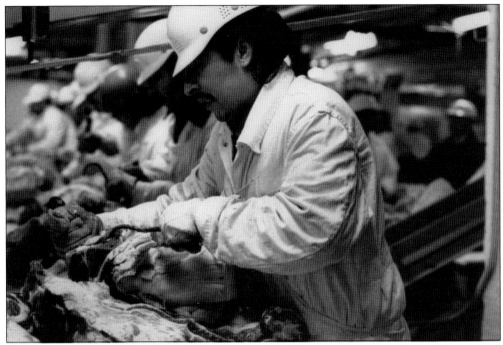

In the 1970s and 1980s, many Latinos, especially Mexicans, continued to work in small meatpacking companies. Here an unidentified Mexican man processes meat in 1975. (Courtesy Chicago History Museum.)

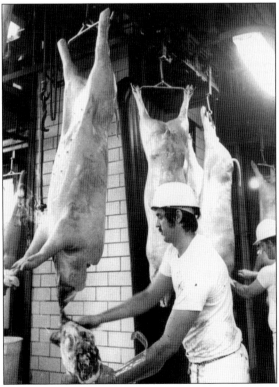

An unidentified Latino man processes meat in a small, Chicago-based meatpacking company in 1975. (Courtesy Illinois Labor History Society.)

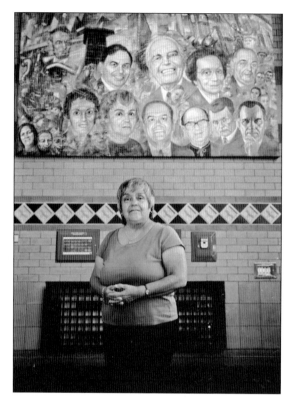

Carmen Velasquez (Mexican) founded the Alivio Medical Clinic in 1989 to serve residents of Pilsen regardless of their ability to pay. She is the executive director of the clinic. She also is co-owner of the popular Decima Musa restaurant in Pilsen. She is standing in front of a picture of her father (top center), a successful businessman, at Arturo Velasquez West Side Technical Institute, a school named after him. (Courtesy Joe Gallo.)

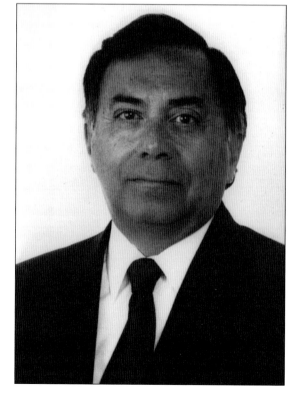

Arturo R. Velasquez (Mexican), brother to Carmen, above, is a successful businessman. He is the founder and president of Azteca Corn Products Corporation, a multimillion-dollar tortilla and corn chip business. The business, with over 130 employees, is located in Chicago's Garfield Ridge neighborhood. (Courtesy Arturo R. Velasquez.)

Pepe's Mexican restaurant, pictured here on Chicago's north side, was established in 1967 by Mario Dovalina (Mexican) and Edwin Ptak. Pepe's restaurants later became franchises. There are now more than 50 Pepe's restaurants in Chicago and the suburbs. (Courtesy Conrad Sulzer Library.)

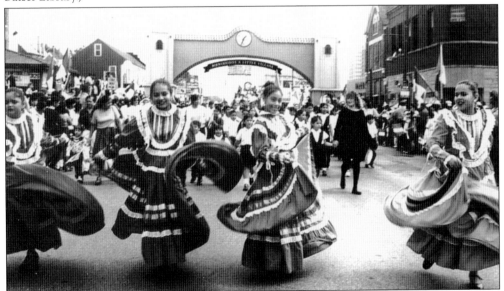

A Mexican Independence parade travels along Twenty-sixth Street in the Little Village neighborhood in the early 1990s. According to the local chamber of commerce, there are more than 1,400 small businesses on the street, which is a little over a mile long. The businesses include restaurants, bakeries, music stores, grocery stores, taverns, barbershops, furniture stores, and other businesses. About 85 percent of the businesses are Mexican-owned and were established many years ago. (Courtesy *La Raza*.)

This is Eighteenth Street in Pilsen in the early 1980s. This is also a popular commercial strip with a lot of Mexican-owned businesses. Most of the businesses are mom-and-pop establishments. The businesses include jewelry stores, bakeries, restaurants, barbershops, and many others. (Courtesy Richard Stromberg.)

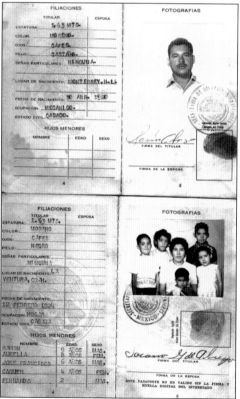

This is the passport of Ramon Abrego (Mexican) and his wife, Socorro, and their five children. They came from Mexico to Chicago as legal residents in 1956. Abrego worked in a small factory in Chicago for 26 years until he retired. Socorro was a homemaker. Two of their sons became medical doctors. One daughter owned two large bakeries in Waugekan. (Courtesy Ramon and Socorro Abrego.)

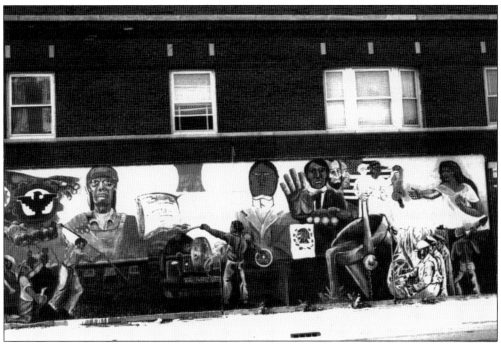

In 1974, Mexican artists attempted to paint this mural in Blue Island, Illinois. The mural shows Mexican workers laboring in the railroads and as migrant workers to then working in heavy industry and the professions. The mayor and city council of Blue Island dubbed the mural as advertisement and graffiti and prevented the artists from completing it. In a lengthy court case, a U.S. district court judge ruled in favor of the artists. (Courtesy Illinois Labor History Society.)

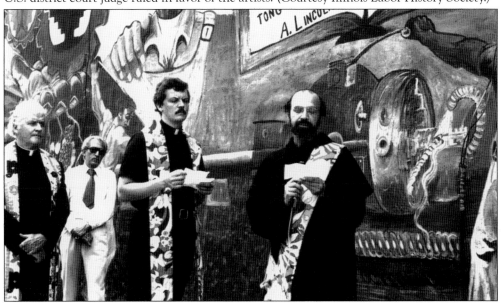

Hundreds of community residents and supporters showed up for a dedication of the "forbidden mural" of Mexican workers in Blue Island. Here in 1974, at the dedication, unidentified Roman Catholic priests bless the mural. The mural was later completed. (Courtesy Illinois Labor History Society.)

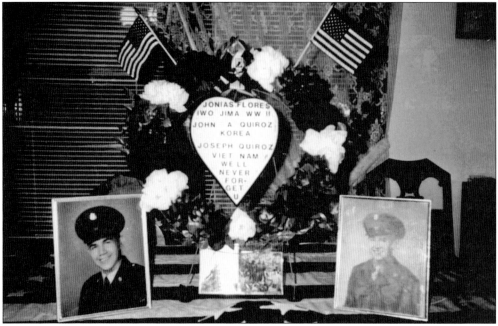

Latino young men hoped their military experience would give them skills and education they could later apply in civilian life. But some Latino men never returned from war. The Quiroz family (Mexican) lost three relatives in three different U.S. wars. A relative maintains this memorial on her dining room table. (Courtesy Mary Quiroz Flores.)

Immigration and Naturalization officials arrested two undocumented Mexican men in 1996. They apprehended the men on the south side of Chicago, where they were illegally working in a factory. The men are wearing immigration tags on their wrists. They were immediately deported back to Mexico. (Courtesy Richard Stromberg.)

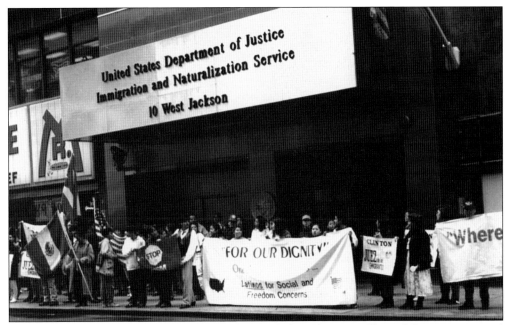

Mexicans and other Latinos protest in front of the Chicago office of Immigration and Naturalization in 1997. The demonstrators wanted immigration officials to stop raids against undocumented workers. They were also protesting changes in immigration laws that made legal residents ineligible for food stamps and social security benefits. The sign on the right asks, "Where did your parents come from?" (Courtesy *La Raza*.)

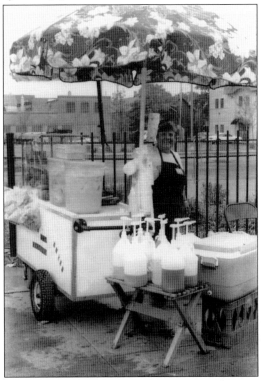

On almost every corner in Chicago are Mexican and Guatemalan street vendors. Esperanza Torres (Mexican), pictured in 1998, is on her corner on Twenty-sixth Street in the Little Village neighborhood. Torres sells tamales, pork skins, corn on the cob, fruit juices, snow cones, sliced watermelon, cucumbers, and mangoes sprinkled with salt, lime juice, and cayenne pepper. She is wearing her city vendor license. (Photograph by Wilfredo Cruz.)

Mexican pushcart vendors came together in 1998 in Little Village to try to form an informal union. The vendors were trying to comply with certain new city ordinances, such as requiring them to buy city vendor licenses. But they were opposed to ordinances limiting their hours of operations and restricting their sales to designated city wards. Their union never did materialize. (Photograph by Wilfredo Cruz.)

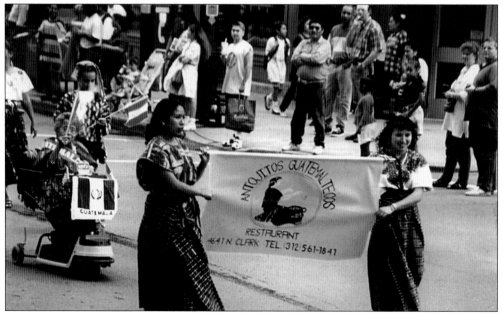

Guatemalans, in traditional Guatemalan dresses, participate in the annual Central American parade in downtown Chicago in 1996. The women are holding a banner advertising a popular Guatemalan restaurant. A small but growing number of businesses have opened on Chicago's north side to cater to the growing Guatemalan community. (Courtesy *La Raza*.)

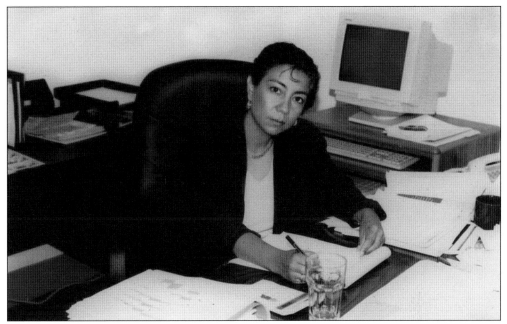

Maricela Garcia (Guatemalan), pictured here in 1998, was the former executive director of the Illinois Coalition for Immigrant and Refugee Rights. The group advocated for the rights of immigrants to jobs, education, health care, and other social services. (Photograph by Wilfredo Cruz.)

Guillermo and Maria Mendizabal (Guatemalan) are pictured here with their daughters vacationing in Florida in 1997. Pictured from left to right are Maria, Mary Jean, Annabela, Brenda, and Guillermo. Guillermo worked for many years as an appliance repairman for Sears department store. Maria worked at the Playskool factory and other small factories. Their daughters were college educated. (Courtesy Guillermo and Maria Mendizabal.)

Adriana Portillo Bartow (Guatemalan) stands in front of a youth center in 1998. The center was operated by the Greater Lawn Community Youth Network, of which Bartow was the director. In Chicago, Bartow regularly speaks to diverse audiences about human rights violations and the violence her family experienced in Guatemala. (Photograph by Wilfredo Cruz.)

Hundreds of Guatemalan workers and their families gathered at Our Lady of Lourdes Church on January 15, 2000. They gather every January 15 to celebrate a special mass and procession in honor of Señor Crucificado de Esquipulas, a black Christ crucified on a wooden cross. The black Christ is very dear to Guatemalans. (Photograph by Wilfredo Cruz.)

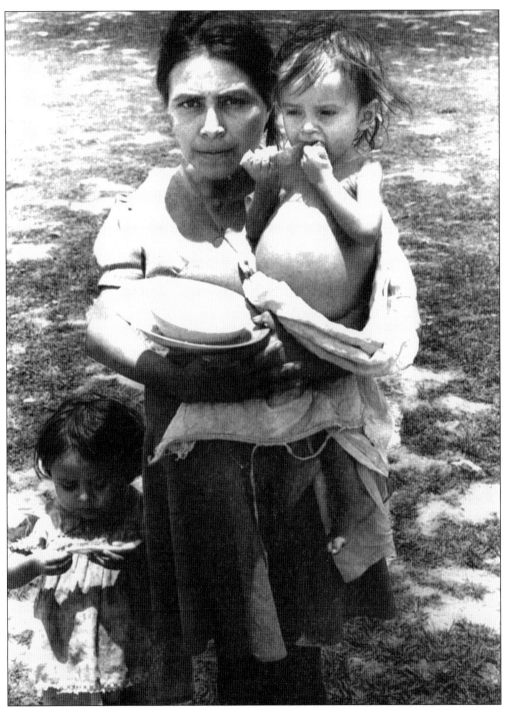

Many South and Central Americans came to Chicago in search of work due to extreme poverty in their countries. This unidentified Salvadoran woman and her children went to Honduras because of poverty in El Salvador. They were in a Salvadoran refugee camp in Mesa Grande, Honduras, in 1982. The baby was suffering from malnutrition. (Photograph by Steve Cagan, courtesy *In These Times*.)

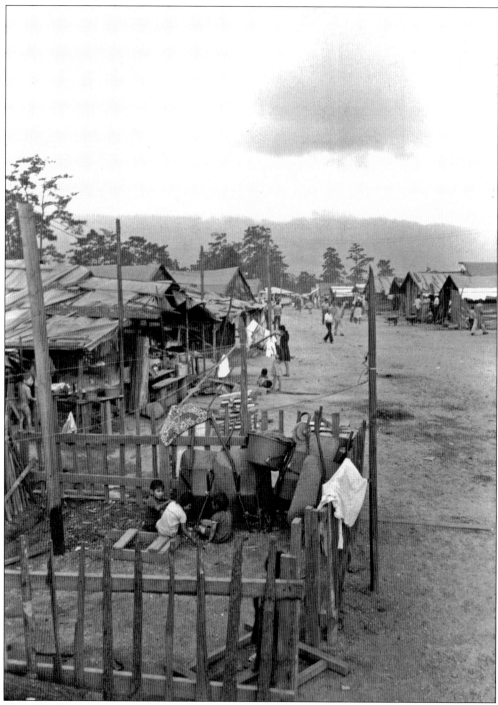

The Salvadoran refugee camp in Mesa Grande, Honduras, is seen in 1982. Many Salvadorans eventually left El Salvador and camps like this and ventured to American cities searching for better-paying jobs. They came to cities like Los Angeles, Texas, Washington, New York, and Chicago. (Photograph by J. Evans, courtesy *In These Times*.)

Judith Alvarado (Salvadoran) is on the right with her daughter. They are standing in front of their apartment building in the Albany Park neighborhood in 1998. Judith emigrated from El Salvador to Chicago in 1982. She worked soldering circuits in an electronics factory in Skokie for many years. (Photograph by Wilfredo Cruz.)

Daisy Funes (Salvadoran) stands in front of Centro Oscar Romero on Chicago's far north side in 2000. She is the longtime executive director of the center. The center provides social services to the growing Salvadoran community. The English and Spanish sign on the window says, "No Human Being is Illegal." (Courtesy Daisy Funes.)

After working hard all day, Salvadoran immigrants in 1997 take an evening English class at Centro Oscar Romero. Some of the participants could barely stay awake. (Courtesy Daisy Funes.)

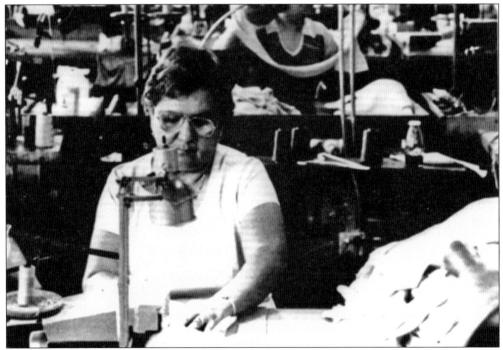

An unidentified Central American woman works in a factory sewing clothes in the early 1970s. (Courtesy Richard Stromberg.)

Rev. Carlos Plazas (Colombian), left, founded St. Augustine College on Chicago's north side in 1984. It was the Midwest's first bilingual college and began in an old warehouse that once served as a film studio for Charlie Chapin. Reverend Plazas became the college's first president. Reverend Plazas is with Nina Vazquez, a student from the graduating class of 1998. (Courtesy St. Augustine College.)

These Latino graduates are from the 1998 graduating class of St. Augustine College. The two-year college awards the associate of arts degree. Most of the students are nontraditional older students from South and Central American countries. They are hoping a college degree will help them find good jobs. (Courtesy St. Augustine College.)

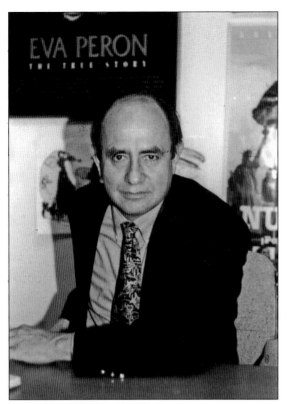

Jose Pepe Vargas (Colombian), shown here in 1998, is the founder of the popular Chicago Latino Film Festival. He is also executive director of the International Latino Cultural Center, which presents performances, dances, films, and plays from many South and Central American countries. (Photograph by Wilfredo Cruz.)

Henry Cardenas (Colombian) is president of Cardenas/Fernandez and Associates, Inc. His company is the biggest promoter of Latino music and sports in the United States. He and his Cuban partner regularly bring famous Latino musical groups to perform in Chicago. Cardenas is shown here in 1998. (Photograph by Wilfredo Cruz.)

David Ernesto Munar (Colombian) is the vice president of public policy for the AIDS Foundation of Chicago. He is shown here in 1998. (Photograph by Wilfredo Cruz.)

Luis Rossi (Uruguay) was the owner of Rossi Publications, Inc., and Rossi Enterprises. He was the owner and publisher of *La Raza* newspaper, Chicago's largest daily Spanish-language newspaper for many years. He later sold the newspaper. He is shown here in 1999. (Photograph by Wilfredo Cruz.)

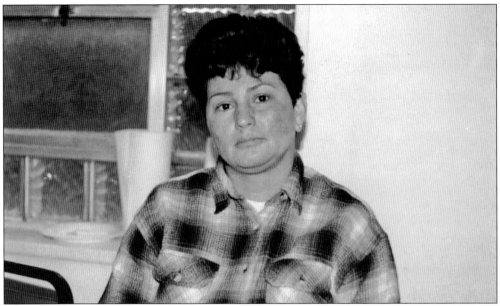

Martha Aquilar (Honduran) came from Honduras to the United States in 1990 hoping to find work to support herself and her three children. She was not able to find work. She and her children instead found shelter at a family homeless shelter in Pilsen. She lived in the shelter for almost a year. She was hoping to find a job soon. She is shown here in 1998. (Photograph by Wilfredo Cruz.)

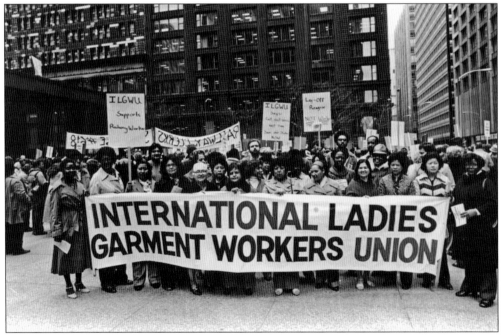

African American, white, Latino, and Asian American members of the International Ladies Garment Union hold a large rally in downtown Chicago in the early 1980s. They were protesting against job cuts and for better government regulations to protect workers' jobs, pensions, and benefits. (Photograph by Sydney Harris, courtesy In These Times.)

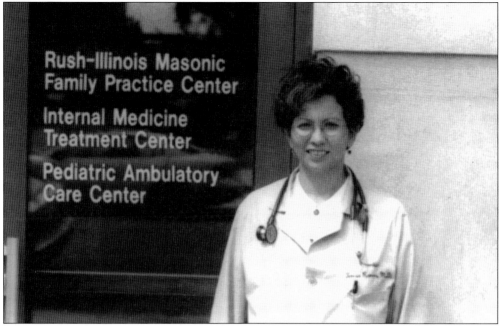

Teresa Ramos (Mexican) is a physician specializing in internal medicine at Illinois Masonic Hospital. She is shown here in 1998. Her parents were migrant workers from Texas. Ramos came to Chicago in 1992. (Photograph by Wilfredo Cruz.)

Rev. Juan Huitrado (Mexican) was one of a handful of Latino priests in Chicago. He was highly respected in the Mexican community. For many years he served as the pastor at St. Pius and at St. Roman Catholic Church. He passed away at age 51 in 2004. He is shown here in 1998. (Photograph by Wilfredo Cruz.)

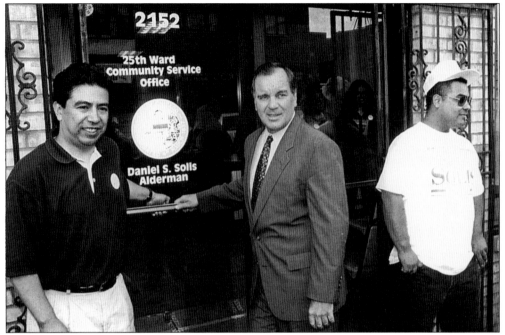

Daniel Solis (Mexican, left) has been the alderman of the 25th Ward since 1996. He is standing with Mayor Richard M. Daley in front of Solis' former aldermanic office in 1996. The individual at right is unidentified. Solis is one of the mayor's strongest supporters. He is the president pro tempore of the city council. (Courtesy Daniel Solis.)

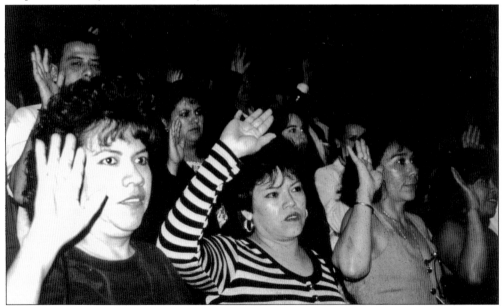

Many Mexicans and Latinos from South and Central America hope to improve their lives by becoming American citizens. Pictured here are thousands of Latinos at a 1997 swearing-in ceremony to become American citizens. The ceremony was sponsored by the Chicago office of Immigration and Naturalization. The United Neighborhood Organization helps many Mexicans become American citizens. (Courtesy United Neighborhood Organization.)

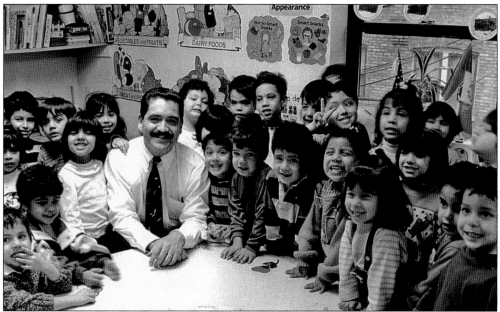

Former Illinois state senator Jesus Garcia (Mexican) is seen with children in the early 1990s. The children are from El Hogar de Nino, a day care center in Pilsen. Garcia served as a state senator for six years and was very active in supporting Harold Washington for mayor in 1983. He now works in the nonprofit sector providing social services to Latinos. (Courtesy Jesus Garcia.)

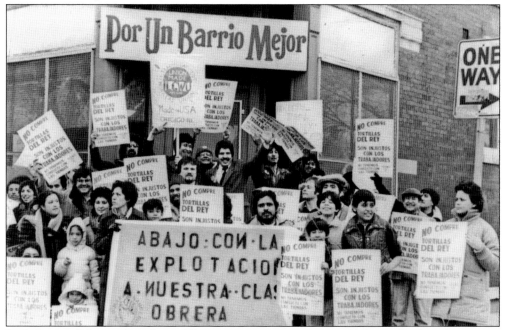

Rudy Lozano (Mexican), in the middle wearing a tie, was a respected labor and political organizer. Lozano was trying to unionize Mexican tortilla makers in the early 1980s. The big sign says, "down with the exploitation of our working class." In 1983, a young man shot and killed Lozano in his home. Many suspected it was because of his labor and political organizing. Two public schools and a library were named in honor of Lozano. (Courtesy Rudy Lozano Public Library.)

Carlos Tortolero (Mexican), along with Helen Valdez, founded the National Museum of Mexican Art in Pilsen in 1987. Tortolero is the executive director of the museum. The museum is the largest, most popular Latino museum in the country. (Courtesy Carlos Tortolero.)

Mary Gonzales (Mexican, left) is here with her mother, Guadalupe Reyes, and her husband, Gregory Galluzzo. Gonzales and Galluzzo are well-known community organizers who founded community-based groups like the United Neighborhood Organization. Reyes founded the Esperanza School, El Valor, and the Guadalupano Family Center, which served physically and mentally challenged children and adults. In 2000, Reyes passed away. (Courtesy Mary Gonzales.)

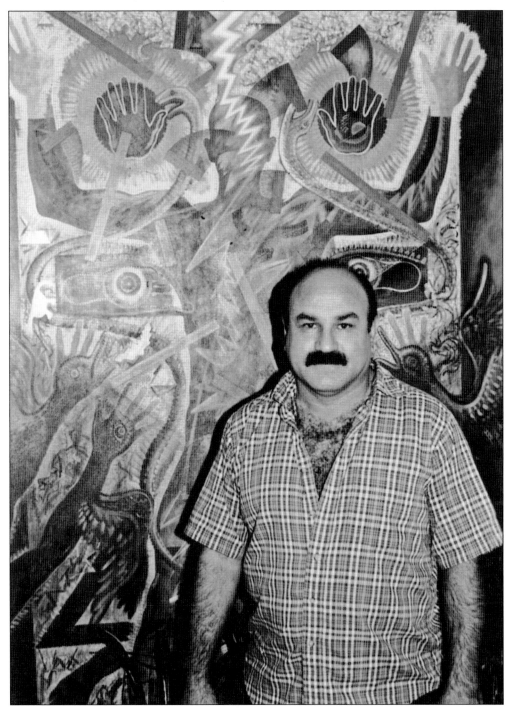

Mario Castillo (Mexican) is a noted muralist and painter. He is credited with launching the Mexican mural movement in Chicago in 1968, when he painted a mural entitled *Peace*, a work paying tribute to the Native American cultures of the Northwest and against the Vietnam War. He is standing next to one of his paintings in 1998. (Photograph by Wilfredo Cruz.)

Luis J. Rodriguez (Mexican, left) is a nationally recognized author, poet, and journalist. His 1993 book, *Always Running, La Vida Loca: Gang Days in L.A.*, won numerous awards. Sadly, his son, Ramiro, pictured right in 1995, was convicted in 1997 of attempted murder of a truck driver and two police. He was sentenced to 28 years in prison. (Courtesy Luis J. Rodriguez.)

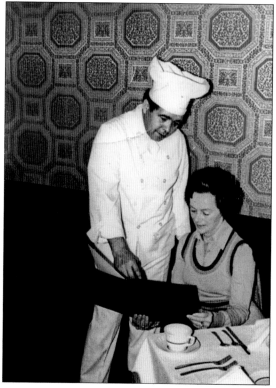

Inocencio Rua Delgado (Puerto Rican) came to the United States in 1950. He worked on farms and later in factories. He eventually found a job at a restaurant and worked his way up to become a chef. The restaurant, called the Cutlass, was located in Stone Park. He worked as the chef for over 10 years. He is pointing out the international cuisine to a customer in the early 1960s. (Courtesy Ivette Velasquez.)

David Mendez (Puerto Rican) came to the United States as a migrant worker in 1950. He found work at the Sylvania Electrical Supply Company in Chicago. He worked for 35 years at Sylvania, where he operated a forklift. He retired with a pension. He raised four daughters and one son. All his children graduated from college. (Courtesy Annie and Eduardo Camacho.)

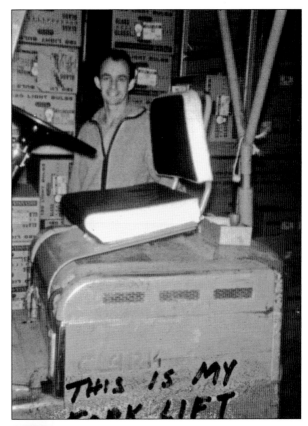

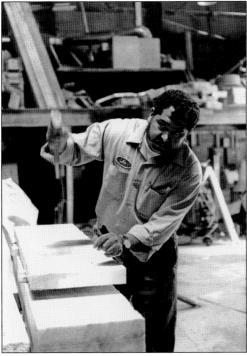

Jose Anibal Rivera (Puerto Rican) is pictured in 1972. Rivera was a skilled stonecutter for the Galassi Cut Stone Company in Worth. He worked for the company for many years. He came from Puerto Rico to Chicago in 1950. (Courtesy Jaime Rivera.)

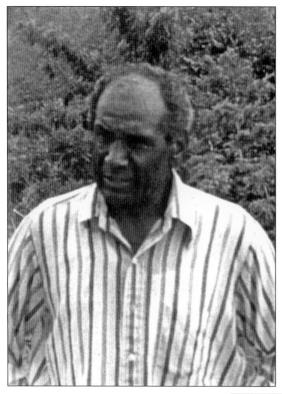

Juan Abedo Gomez is believed to be the first Puerto Rican police officer with the Chicago Police Department. Gomez joined the department in 1960, worked on the force for over 27 years, and earned the rank of sergeant. Because Gomez was dark skinned, he had a hard time joining the department because of prejudice within the department during the 1960s. Gomez passed away in 2003. (Courtesy Efrain López.)

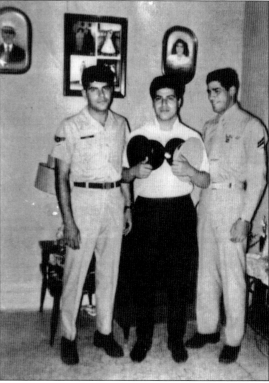

Pictured here in the early 1960s are three brothers (Puerto Rican) who made their careers in the U.S. military. From left to right are Edwin, Monserrate, and William Diaz. Edwin served in the U.S. Air Force for 30 years, obtaining the rank of chief master sergeant. He saw action in Vietnam and Desert Storm. Monserrate served for 8 years in the U.S. Air Force and retired from the Army National Guard as a sergeant. William served for 14 months in Vietnam with the U.S. Marine Corps and another 4 years in the marine reserves. He earned the rank of sergeant. (Courtesy Hilda Frontany.)

Raul Cardona (left), shown here in 2003, is a well-known Puerto Rican radio personality. For many years he played Puerto Rican and Spanish music and news on his popular *Raul Cardona* radio program. Also pictured is his son, Felix. The two are businessmen who own record stores, dance halls, and apartment buildings in the Logan Square neighborhood. (Photograph by Wilfredo Cruz.)

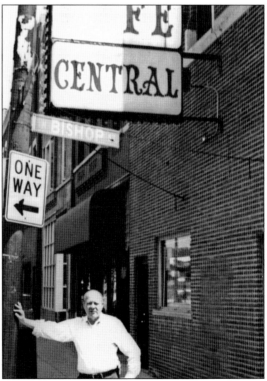

Café Central opened in 1954 and is one of the first Puerto Rican restaurants in Chicago. The restaurant extended credit to single Puerto Rican men working as factory laborers in the 1950s. Pictured here is Rafael Cruz in 2003. His uncle and father owned the restaurant previously. Today Cruz and his wife are the owners. The restaurant is located on Chicago Avenue and Bishop Street, and while few Puerto Ricans live in the gentrified neighborhood, they still patronize the restaurant. (Photograph by Wilfredo Cruz.)

Carlos Caribe Ruiz (Puerto Rican) established the Puerto Rican Congress on North Avenue in 1952. The organization sponsored baseball and basketball leagues for youth. The organization also taught generations of Puerto Rican youth how to dance, play, and appreciate traditional and modern Puerto Rican music. Several well-known salsa bands were formed at the congress. Ruiz, shown here, was a renowned musician and dancer. He passed away in 1987. (Courtesy Joseph A. Ruiz.)

Hiran Zayas (Puerto Rican), shown here in 1970, was born with physical disabilities. He lived for many years in Chicago. Zayas graduated from college and writes and uses a computer with his feet. He designed a steering device and pedals that allow him to drive his van. He lives in Buffalo, Michigan, where he runs a residential center for people with mental and physical disabilities. (Courtesy Tomas V. Sanabria.)

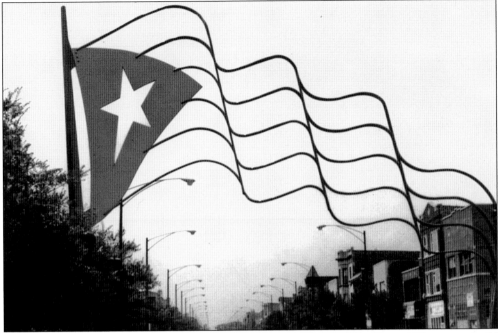

In 1995, Puerto Rican community leaders and politicians pressured the City of Chicago to build two steel, 59-foot flags on Division Street. One flag is by Western Avenue, and the other is about six blocks west on California Avenue. The area within the flags is a small commercial district called *Paseo Boricua* (Puerto Rican Public Square). Of about 120 businesses on the strip, 88 are Puerto Rican–owned. Shown here is the flag on Western Avenue. (Photograph by Wilfredo Cruz.)

Lily's Record Shop on Paseo Boricua has been at the same location for over 25 years. It is a popular store for buying CDs, videos, dominoes, shirts, flags, and other Puerto Rican goods. The owner is Carmen Martinez (Puerto Rican), right. She is pictured in 2008 with Sgt. Julio Velgara (Puerto Rican). (Courtesy Luis Cabrera.)

Coco is an elegant, upscale restaurant that opened its doors on Paseo Boricua in February 2004. It is the only high-end Puerto Rican restaurant in Chicago. Thus far business has been brisk. The owner is Jose Allende (Puerto Rican). (Courtesy Puerto Rican Cultural Center.)

Maddi Amill (Puerto Rican) is pictured here in 2009. She is the owner of El Quijote bookstore on Paseo Boricua. The bookstore specializes in Puerto Rican and Latino literature. It has been on Division Street for over 25 years. (Photograph by Wilfredo Cruz.)

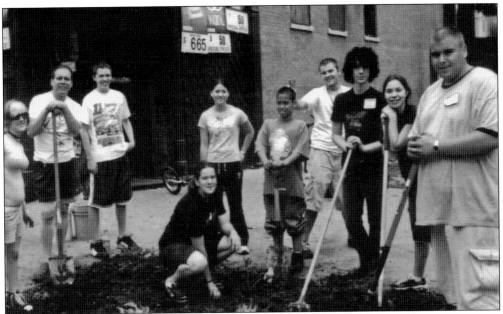

Rev. Tomas V. Sanabria (left, hands on shovel) is a well-known Puerto Rican Pentecostal minister in the Humboldt Park community. He is shown here in 2007 working with youth in planting flowers on a street corner in Humboldt Park. The youth are from other cities and states and annually visit inner-city communities to perform missionary work. (Courtesy Tomas V. Sanabria.)

This was a job fair at Casa Puertorriqueña in Humboldt Park in 2006. A good number of Puerto Ricans and other Latinos attended the fair. They filled out job applications with different companies hoping to find a steady job. (Courtesy Luis Cabrera.)

Angela Rodriquez (Puerto Rican) is with her grandchildren, Stephanie Rivera and Damian Andrew Roman, in her home in 1998. In the past, Rodriguez led a hard life, selling and abusing drugs. She served six years in jail for shooting and partially paralyzing an abusive boyfriend. She now works as a computer programmer, owns a condominium, and is a self-taught auto mechanic and mural painter. (Photograph by Wilfredo Cruz.)

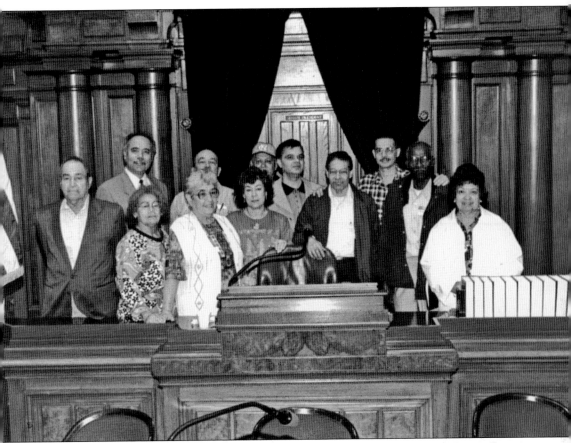

Former Illinois state senator Miguel del Valle (Puerto Rican, with tie) met with Puerto Rican and Cuban seniors in the chambers of the Illinois General Assembly in Springfield. The seniors visited the senator during a lobby day in 1997. Del Valle was elected senator in 1987. He is now the city clerk for the City of Chicago. (Courtesy Miguel del Valle.)

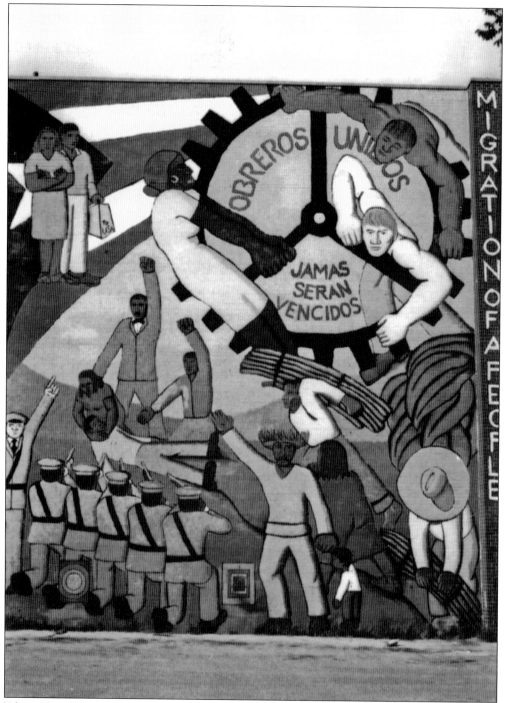

Ed Maldonado and Bo Solari painted this three-story mural titled *Migration of a People* on a building in the West Town neighborhood in 1974. The mural shows the migration of Puerto Ricans to the United States, police brutality, and the exploitation of workers. The Spanish words on the mural say, "workers united will never be defeated." (Courtesy Marixsa Alicea.)

Three

WORK OF THE PRESENT

Many second- and third-generation Latinos have made significant economic progress, holding professional jobs in education, government, criminal justice, social services, business, religion, politics, and other white-collar occupations. Many own their homes. Others own small, thriving mom-and-pop businesses. And more Latinos continue moving into middle-class, suburban neighborhoods.

However, a good number of Latinos, and other Americans, are hurting economically. Since late 2007, the United States has been in a deep recession. In January 2009 alone, 600,000 American jobs were lost, bringing the total thus far to 3.6 million jobs since the recession began. Personal bankruptcy is at an all-time high. Home foreclosure is at an all-time high. Many blue-collar and even college-educated Latinos cannot find jobs in this terrible economic crisis.

Some Chicagoans and other Americans believe Latinos refuse to integrate and are replicating their own culture in the United States. They believe undocumented Latinos drain the economy by seeking health, education, and social services to which they are not entitled. Yet Latino immigration to the city continues.

Immigrants from countries like Colombia continue to arrive in Chicago. Some are middle-class, educated professionals who are lured to cities like Chicago, where jobs and advancement opportunities are supposedly better. Others are unskilled workers fleeing political violence and economic hardship in their homeland. It is estimated that there are over 35,000 Colombians in the Chicago area.

New emigrants from South and Central American countries continue coming to Chicago as poor, unskilled, undocumented workers. Like earlier Latino immigrants, these newcomers seek decent wages and steady jobs. By coming to places like Chicago, they believe they have nothing to lose and everything to gain. They prefer to try their luck in Chicago rather than return and face civil strife, poverty, and unemployment in their homelands.

Surely these newcomers will encounter obstacles. Chicago is vastly different from what it was 75 years ago. Well-paying manufacturing jobs that previous immigrants used to get a foothold into the middle class have been lost to Third World countries. Chicago's economy is steadily being transformed into a service economy. Occupations at the higher end of the growing service industries require a college education and specialized, skilled workers. Only time will tell how newer Latino workers adapt and adjust in Chicago.

In 1969, Ron Baltierra (Mexican) was a combat sniper in Vietnam. Baltierra is seen here in Binh Phun, Vietnam. Baltierra now owns a construction company in Chicago. His company built the Mexican-style arch gateway in the Little Village neighborhood at Twenty-sixth Street and California Avenue. (Courtesy Ron Baltierra.)

An unidentified Mexican man makes his living shining shoes in downtown Chicago in 1995. (Courtesy *La Raza*.)

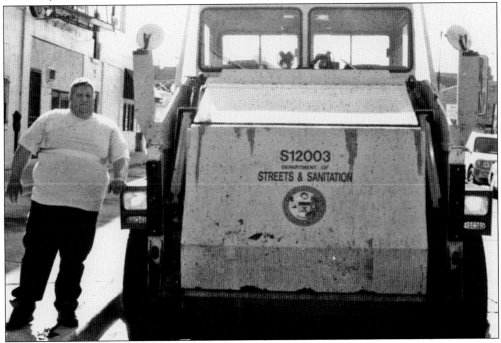

Juan Delgado (Puerto Rican) has been a street cleaner with the City of Chicago for nine years. Traditionally, to land high-paying jobs in various city departments like Streets and Sanitation, a person needed good old-fashioned clout or political connections. (Photograph by Wilfredo Cruz.)

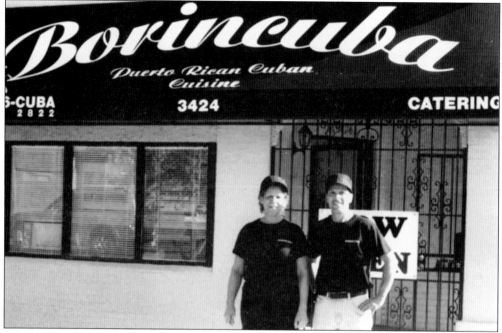

Aracelia Rodriguez and her brother, Efrain Aquilera (Cuban/Puerto Rican), proudly stand in front of their restaurant, Borincuba, which opened in 2007 on Chicago's north side. The restaurant served both Puerto Rican and Cuban cuisine. Unfortunately, after two years of business, the restaurant did not make it and folded. (Photograph by Wilfredo Cruz.)

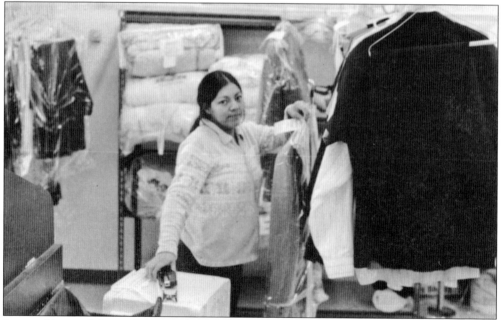

Leticia Alvarez (Mexican) was working at a dry cleaners on Chicago's north side ironing and pressing clothes in 2008. Shortly after this photograph was taken, Alvarez and nine other Mexican workers were fired. To save money, the cleaners sent their clothes to a Wisconsin firm. (Photograph by Wilfredo Cruz.)

Cory Rodriguez (Puerto Rican/Italian) worked collecting money from meters for a private company for two years. In 2007, the City of Chicago leased its meters to a private company for the next 75 years. The company immediately raised the price of meter parking four-fold, angering many Chicagoans. (Photograph by Wilfredo Cruz.)

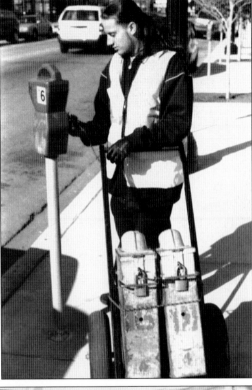

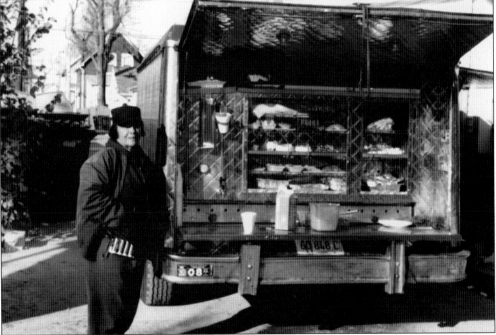

Guadalupe Salinas (Mexican) is from Texas. She is shown here in 2007. She has sold food from her café truck for over 30 years. She travels all across the city to construction sites selling her Mexican and American food to Latino construction workers. (Photograph by Wilfredo Cruz.)

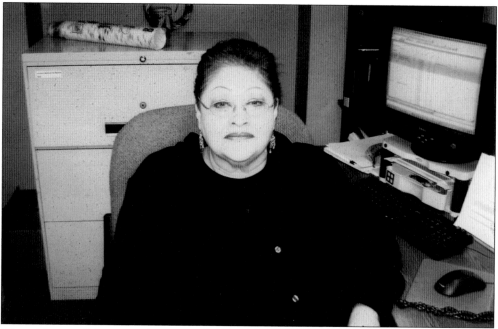

Diana Vanegas (Nicaraguan) came to the United States in 1966. She worked as a secretary for Chicago's City Colleges and other small firms for many years. She has been the secretary of the photography department at Columbia College Chicago since 1996. She is looking forward to soon retiring. (Photograph by Wilfredo Cruz.)

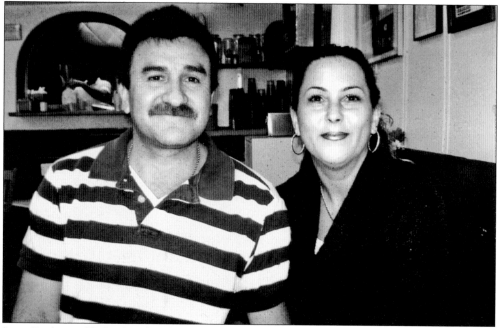

Jorge Gacharna (Colombian) and his wife, Jeannette (Puerto Rican), have owned two restaurants on Chicago's north side for the last 13 years. Their restaurants, like La Brasa Roja, specialize in Colombian cruise, especially delicious chicken slowly cooked over charcoal. They soon plan to open a third restaurant. (Photograph by Wilfredo Cruz.)

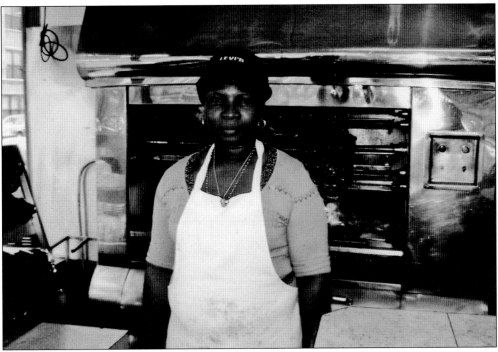

Martha Hinestroza (Colombian) works as a cook and waitress at La Brasa Roja restaurant. (Photograph by Wilfredo Cruz.)

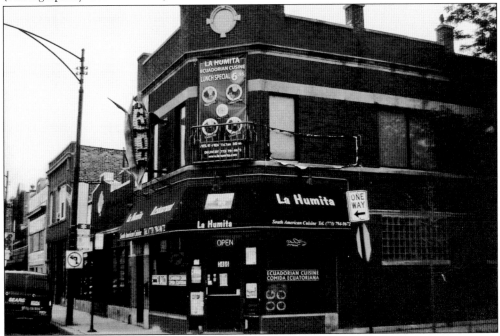

A popular Ecuadorian restaurant on Chicago's north side is La Humita. The restaurant was founded in 2003 by Nestor, Ulpiano, and Luis Correa. The Correa brothers are three Ecuadorians who came to the United States seeking better economic opportunities in the early 1990s. (Photograph by Wilfredo Cruz.)

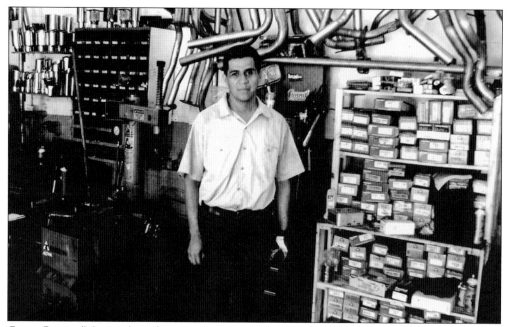

Cesar Garcia (Mexican) works as a mechanic in a small shop on the city's north side. He has been an auto mechanic for about 20 years. (Photograph by Wilfredo Cruz.)

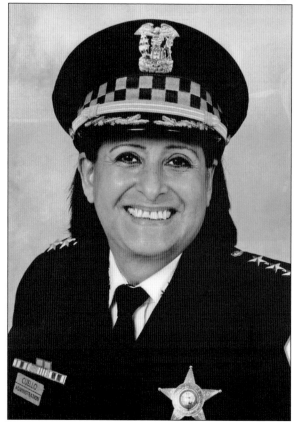

Beatrice Cuello (Mexican) is the highest-ranking Latina in the Chicago Police Department. In 2008, Cuello was promoted to assistant superintendent for administrative services, making her third in command of Chicago's almost 14,000 police. Cuello oversees the bureaus of professional standards and administrative services. (Courtesy Beatrice Cuello.)

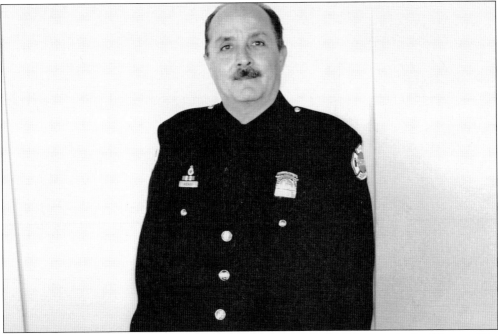

Gregory J. Vicencio (Mexican) has served for 33 years as a firefighter with the Chicago Fire Department. He works in the Little Village neighborhood. (Photograph by Wilfredo Cruz.)

Luis Cabrera (Cuban/Dominican) has been a professional photographer in Chicago for many years. His photography business, FACE Photo, Inc., is located on Paseo Boricua. He is shown here in the Humboldt Park neighborhood in 2008. (Photograph by Deborah A. Laureano, courtesy Luis Cabrera.)

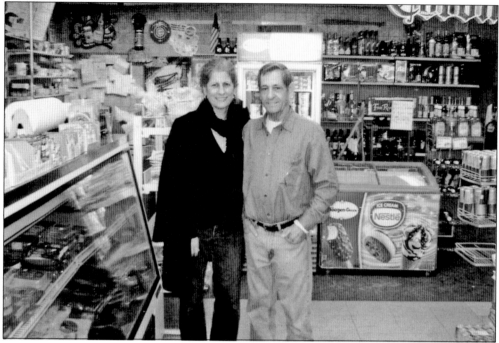

Jose Luis Cepero (Cuban) and his wife, Nancy (Italian), own a grocery and liquor store on Chicago's north side. They have owned the store for about 30 years. Most of their customers are Latino. They are shown here in 2008. (Photograph by Wilfredo Cruz.)

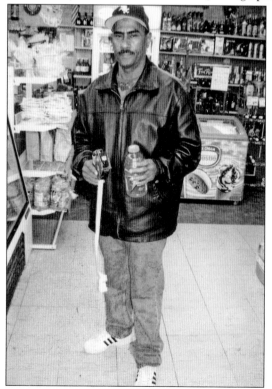

Ivan Beras (Cuban) works in the grocery and liquor store owned by Jose and Nancy Cepero (above). He works stocking produce and liquor. He came from Cuba to Chicago in 1980. (Photograph by Wilfredo Cruz.)

Brothers Alexander (right) and Jose Gato (Cuban), seen here in 2008, own a jewelry store called Gato and Sons on Chicago's north side. Their late father started the business in 1960, shortly after he arrived in Chicago from Cuba. (Photograph by Wilfredo Cruz.)

Ivan Daniel Taylor (Cuban), seen here in 2008, is a janitor at Columbia College Chicago. He came from Cuba to Chicago in 1999. (Photograph by Wilfredo Cruz.)

Some Puerto Ricans make a living playing music all across the city. This is a local salsa group called Tarzan y su Orquesta playing salsa during the 2008 Fiestas Puertorriqueñas in Humboldt Park. The man with the dark shirt is Edwin Santiago (Puerto Rican), the manager of the band. (Photograph by Noraida Burgos, courtesy Luis Cabrera.)

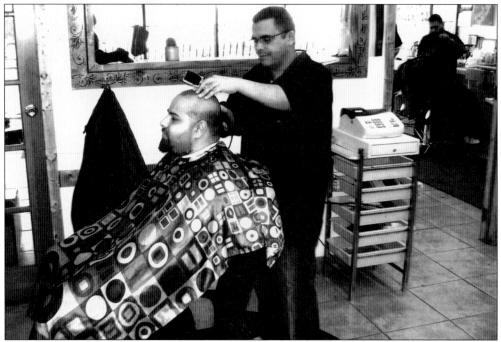

Barber Raynaldo Oquendo (Puerto Rican) is the owner of Jayuya Barber Shop on Paseo Boricua. He has been in business for 15 years. He has 10 barbers working in his popular shop. He is shown here cutting a customer's hair in 2009. (Photograph by Wilfredo Cruz.)

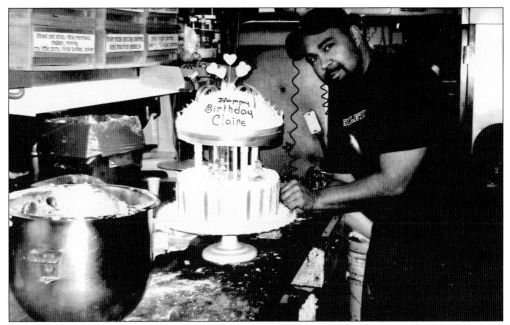

Orlando Serrano (Puerto Rican) puts the finishing touches on a birthday cake. He has been a baker with Roser's Bakery for 14 years. Roser's is a German-owned bakery that has been in the same location in Humboldt Park for 88 years. Three generations have owned the bakery. (Photograph by Wilfredo Cruz.)

Samuel Betances (Puerto Rican) earned his doctorate at Harvard University. For over 25 years, he was a popular professor of sociology at Northeastern Illinois University. He is an engaging speaker who gives lectures on race relations all across the country. He and his wife run their own highly successful consulting firm addressing employment diversity. Many of their clients are city and state governments as well as Fortune 500 companies. (Courtesy Samuel Betances.)

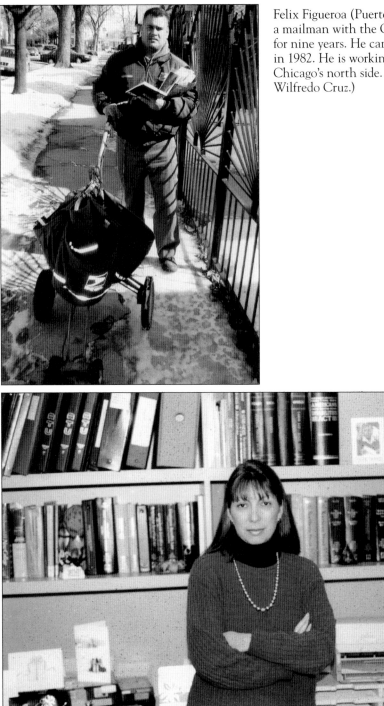

Felix Figueroa (Puerto Rican) has been a mailman with the Chicago Post Office for nine years. He came to Chicago in 1982. He is working his route on Chicago's north side. (Photograph by Wilfredo Cruz.)

Marisel Ayabarreno Hernandez is a Puerto Rican attorney and a partner in the law firm of Jacobs, Burns, Orlove, Stanton, and Hernandez. She specializes in labor law and represents individuals in employment discrimination cases. Her parents worked in factories in New York. She is shown here in her office in 1998. (Photograph by Wilfredo Cruz.)

Noel and wife Marcia Ruiz (Puerto Rican) are seen here in the late 1990s with their three sons, Nathan Anthony (front), Joel Brian (center), and Noel Ryan. Noel is a journeyman carpenter, and Marcia is an elementary school teacher for the Chicago Public Schools. For many years Puerto Ricans could not enter apprenticeship training programs in the building trades in Chicago due to favoritism and discrimination in the unions controlling the programs. (Courtesy Noel and Marcia Ruiz.)

Puerto Ricans participate in various professions. Shown here in 2008, from left to right, are state representative William Delgado (D-Chicago); state representative Luis Arroyo (D-Chicago); Xavier Nogueras, president, Puerto Rican Chamber of Commerce of Illinois; Chicago alderman (30th Ward) Ariel E. Reboyas; and Richard L. Rodriguez, president, Chicago Transit Authority. (Courtesy Luis Cabrera.)

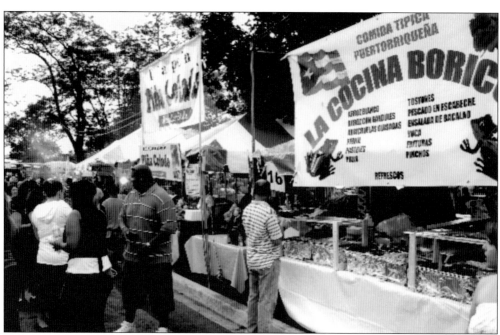

Shown here in 2008 are Puerto Rican vendors selling Puerto Rican food during Fiesta Boricua in Humboldt Park. Over 100,000 people attend the one-day Fiesta Boricua, which is held annually in early September. (Photograph by Carlos Soria, courtesy Luis Cabrera.)

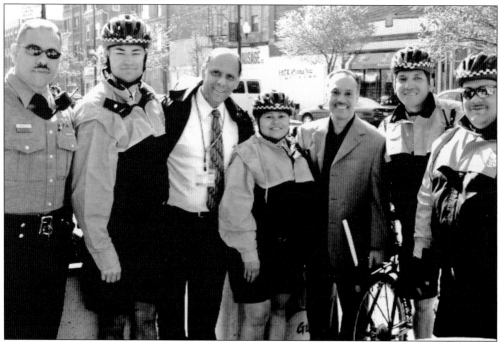

This is the bicycle patrol from the 14th Chicago Police District in Humboldt Park in 2008. Pictured from left to right are Ricky Badilla (Puerto Rican), Matt Hoja (white), Sgt. Julio Velgara (Puerto Rican), Marilyn Gomez (Puerto Rican), former alderman Billy Ocasio (Puerto Rican), Caesar Echeveria (Ecuadorian), and Abraham Crespo (Puerto Rican). (Courtesy Luis Cabrera.)

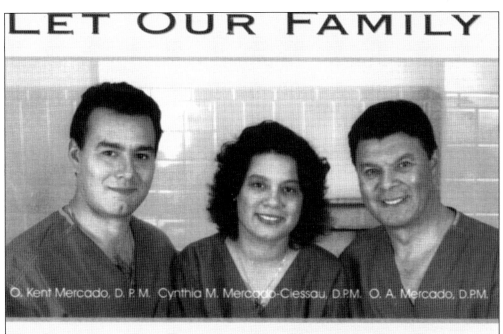

LET OUR FAMILY

O. Kent Mercado, D. P. M. Cynthia M. Mercado-Ciessau, D.P.M. O. A. Mercado, D.P.M.

CARE FOR YOUR FAMILY

O. A. Mercado (right) is a nationally known Puerto Rican doctor in the field of podiatric medicine. He was professor of surgery at the School College of Podiatric Medicine. He has written six books in his field of expertise. His daughter Cynthia M. Mercado Ciessau (center) and his son Kent Mercado (left) are also doctors in podiatric medicine. Together they run four Mercado Foot and Ankle clinics in the nearby suburbs of Chicago. (Courtesy O. A. Mercado.)

Rev. Eddie De Leon (Puerto Rican) has been the provincial superior of the Claretian Missionaries, Eastern Province, in Chicago since 2004. The Claretians (a Roman Catholic order of priests and nuns) began working in Chicago with the Mexican community in 1928 at Our Lady of Guadalupe Church. He was ordained as a priest in 1991 at Holy Cross Church in Chicago. (Photograph by Wilfredo Cruz.)

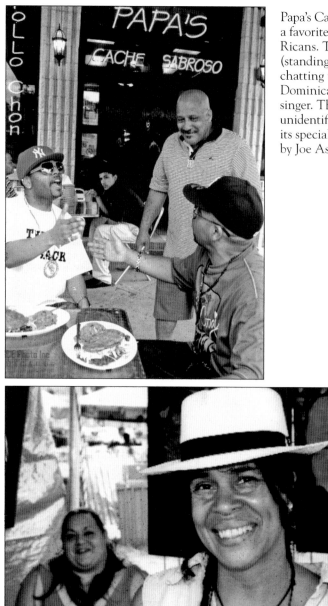

Papa's Cache on Paseo Boricua is a favorite restaurant among Puerto Ricans. The owners are Victor Garcia (standing) and his wife, Nancy. Victor is chatting with Toby Love (Puerto Rican/Dominican), left, a popular local rap singer. The individual to the right is unidentified. The restaurant is known for its specialty, roasted chicken. (Photograph by Joe Asencios, courtesy Luis Cabrera.)

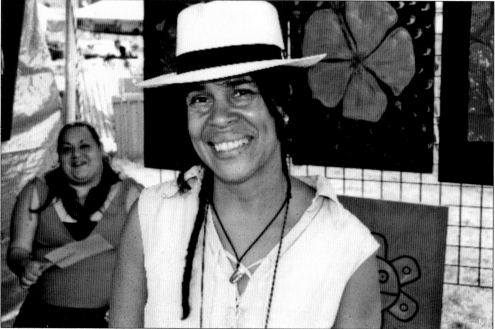

Cuca Cartagena (Puerto Rican) is a well-known artist and painter. Her art reflects many aspects of the Puerto Rican culture. She is shown here in Humboldt Park in the summer of 2008 selling her artwork. The woman in the background is Vanessa Roman (Puerto Rican). (Photograph by Noraida Burgoa, courtesy Luis Cabrera.)

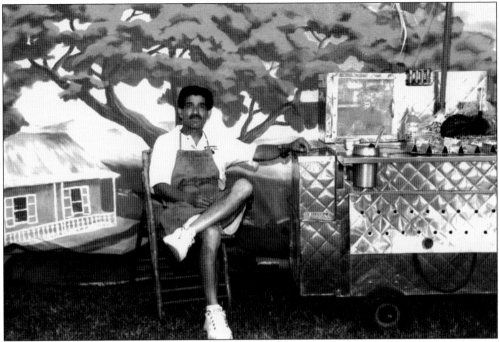

Hector DeJesus makes his living selling hot dogs and soda pop on Crystal and California Avenues. Hector has been selling on his corner for over 14 years. His is sitting next to his hot dog cart. He is shown here in 2008 in Humboldt Park, having his picture taken in front of a canvas mural of a typical 1940s home in Puerto Rico. (Courtesy Luis Cabrera.)

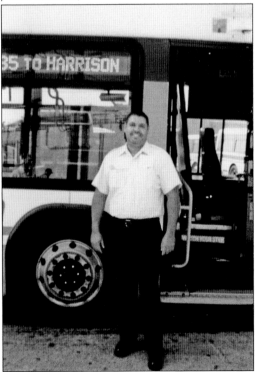

Juan J. Roldan (Puerto Rican) is a bus driver with the Chicago Transit Authority (CTA). He has been with the CTA for two years. He came from Puerto Rico to Chicago in 1979. (Photograph by Wilfredo Cruz.)

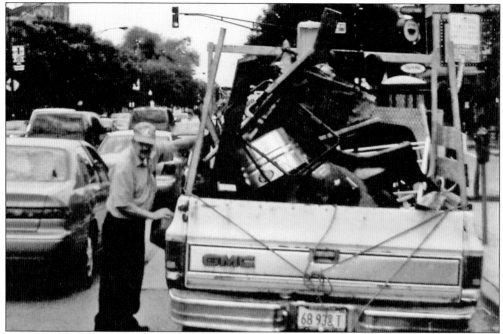

An unidentified Puerto Rican man pours gasoline into his pickup truck in the Logan Square neighborhood in 2009. He makes his living picking up scrap metal from alleys. (Photograph by Wilfredo Cruz.)

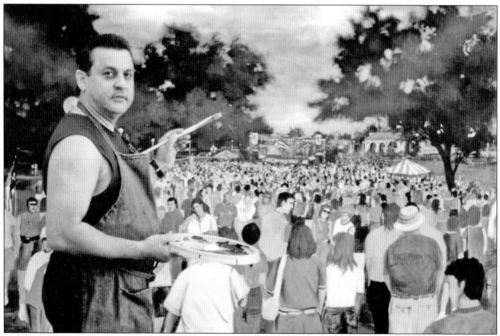

Angel Neris (Puerto Rican) works with the City of Chicago Aviation Department. But he is also a noted artist who paints images of Puerto Rico and Chicago's Puerto Rican community on large canvas. He is painting this colorful canvas mural of Puerto Ricans celebrating in Humboldt Park in 2008. (Courtesy Luis Cabrera.)

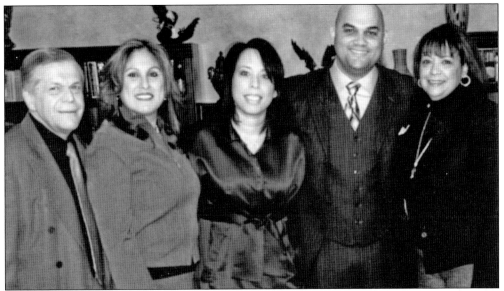

Shown here in 2008 are, from left to right, José López (Puerto Rican), director of the Puerto Rican Cultural Center; state representative (D-Chicago) Cynthia Soto (Mexican); Lynette Santiago (Puerto Rican) co-pastor of Iglesia Rebano; Freddy Santiago (Puerto Rican) co-pastor of Iglesia Rebano; and state representative (D-Chicago) Iris Martinez (Puerto Rican). (Courtesy Luis Cabrera.)

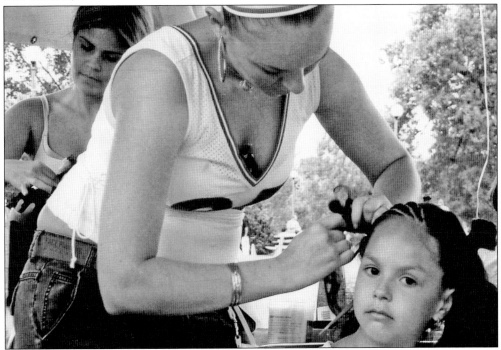

Lisandra Lebrón (Puerto Rican, foreground) is braiding the hair of an unidentified Puerto Rican girl. Lebrón is charging customers for haircuts and braiding under her tent during the 2008 Fiesta Boricua in Humboldt Park. Behind Lebrón is Kristin McCaffrey, also braiding a young girl's hair. Lebrón is owner of Sports Kutz, a popular hair shop on Paseo Boricua. (Courtesy Luis Cabrera.)

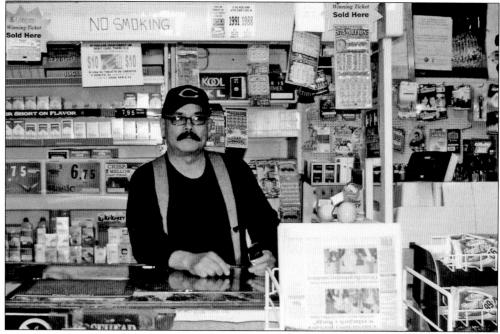

Noel López came to Chicago from Puerto Rico in 1969. He drove a truck for 10 years. He is now the manager for a small grocery and liquor store on Chicago's north side. He has been manager for 17 years. He is proud to say he has a daughter in college. (Photograph by Wilfredo Cruz.)

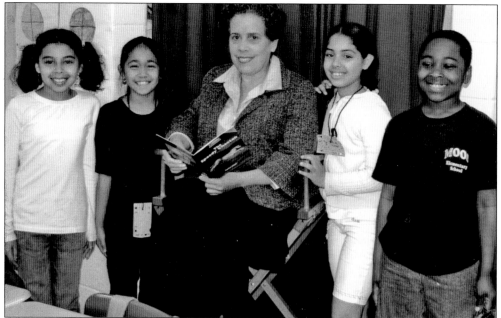

Maria E. Cruz was born in Chicago after her parents migrated from Puerto Rico. She is one of seven children raised in the Cabrini Green Housing Project. She earned two master's degrees. She worked with the Chicago Board of Education for many years, climbing up through the ranks. She is currently the principal of Bernhard Moos Elementary School in Humboldt Park. She is surrounded by her students. (Courtesy Maria E. Cruz.)

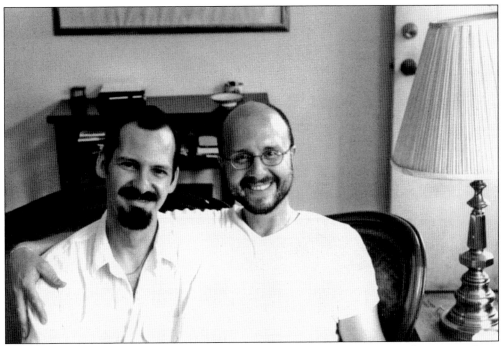

Carmelo Esterrich (Puerto Rican, right) came to Chicago in 1987 from Rio Piedras, Puerto Rico. He is shown here in 2000 with his partner, Joseph Myers (white). The couple has been together for over 26 years. Esterrich is a professor of Spanish at Columbia College Chicago. Myers is an acoustics consultant. (Courtesy Carmelo Esterrich and Joseph Myers.)

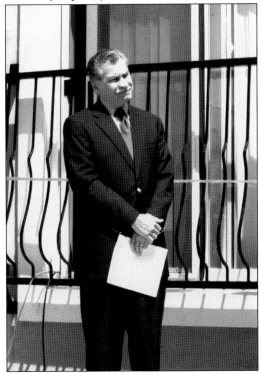

Hipolito (Paul) Roldan (Puerto Rican) has been the executive director of the Hispanic Housing Development Corporation (HHDC) for over 33 years. HHDC is a nonprofit agency that has developed over 1,900 affordable apartments and town houses for Latino families. In 1998, Roldan was awarded a $250,000 Genius Grant from the MacArthur Foundation. He used $100,000 of his grant to establish a college scholarship to attract Latinos in the community development field. (Photograph by Luis Cabrera, courtesy HHDC.)

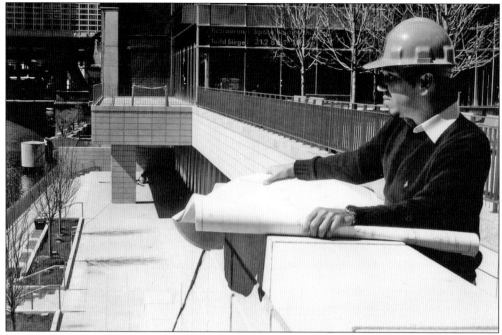

Hector Gonzalez (Puerto Rican) is assistant superintendent for Tropic Construction, a firm that builds affordable housing in Latino neighborhoods. Tropic Construction has built homes for the HHDC. Gonzalez manages the subcontractors on many of the building projects. (Courtesy HHDC.)

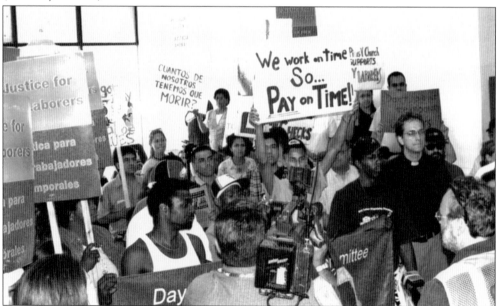

In 2003, angry African American and Latino day laborers marched into Ron's Temporary Help Services, 2413 South Western Avenue. There were many complaints that Ron's was taking advantage of workers by not paying workers all their hours and charging them for rides to work sites in overcrowded, unsafe vans. The city's day-labor ordinance states that day-labor agencies must provide free transportation to and from work sites. (Courtesy Chicago Workers' Collaborative.)

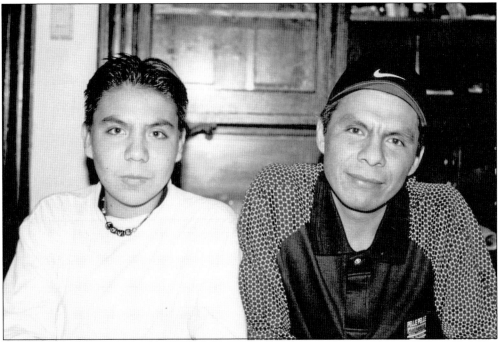

Martin Jaimes (right) and his son Edgar are shown here in 1999 in their Logan Square apartment. Jaimes is an undocumented worker from Mexico. He working for many years for temporary, day-labor agencies. He says the pay is low, the hours are long, and that he does not receive any health insurance or other benefits. He was hoping to find a steady job. (Photograph by Wilfredo Cruz.)

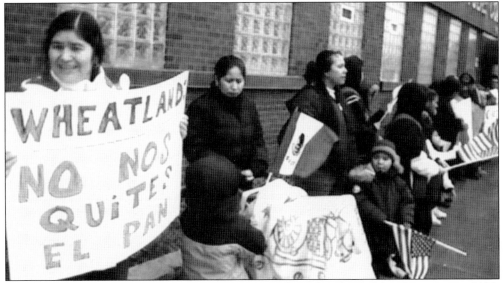

Mexican and other Latino workers protest against the Wheatland Tube Company in 2008. Wheatland is a large plant along South Western Avenue. The workers are protesting the unjustified firing of fellow workers. Wheatland had fired some workers who had attended a press conference supporting other workers who had been fired and who filed a complaint with the Equal Employment Opportunity Commission. The Spanish sign says, "Wheatland don't take away our bread." (Courtesy Chicago Workers' Collaborative.)

Mexican workers confront the owner (right) of Western Cleaners in West Town in 2005. The owner had contracted the workers from Mexico to work in his plant. But the workers were paid less than minimum wage, subjected to hazardous chemicals, and allegedly often beaten by the owner. The workers filed a lawsuit and won back wages and punitive damages. The workers went back to Mexico. (Courtesy Chicago Workers' Collaborative.)

An unidentified Mexican man makes his living selling ice cream for a large ice-cream company. Many Mexican and Guatemalan men make a living as street vendors selling ice cream, tamales, and snow cones. (Photograph by Noraida Burgos, courtesy Luis Cabrera.)

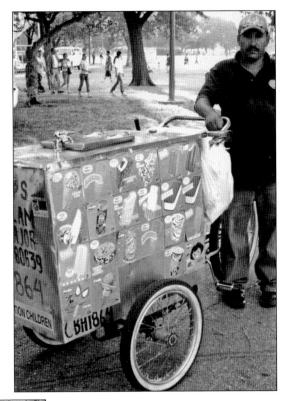

An unidentified Mexican man sells cotton candy and homemade fried pork skins on Chicago's south side. (Photograph by Wilfredo Cruz.).

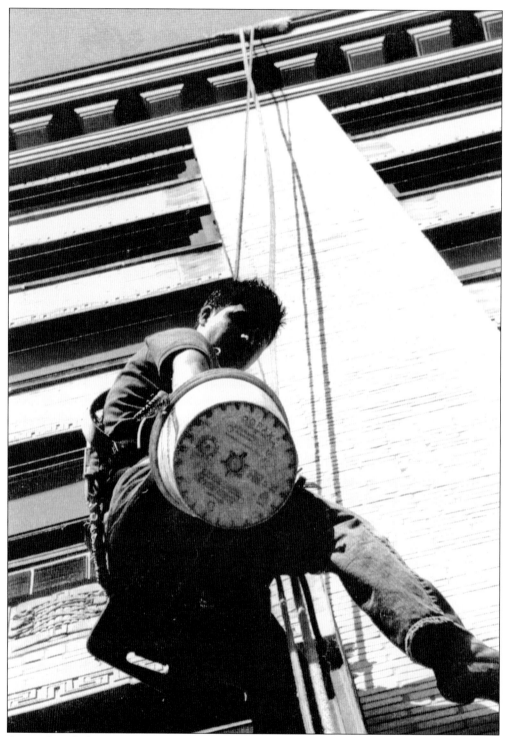

An unidentified Mexican window washer precariously hangs 40 feet up while cleaning windows at 33 East Jackson Boulevard in 2008. Many of the window washers of downtown office buildings are of Mexican background. (Courtesy Columbia Chronicle.)

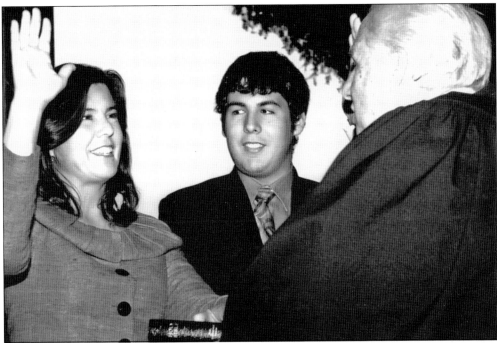

In December 2008, Anita Alvarez (Mexican) made history when she was sworn in as Cook County's first female and first Latina state's attorney. Her son, Jimmy, looks on. It is in the courtroom that Alvarez has felt most at home during the 22 years she has served in the Cook County's state's attorney office. A Chicago native, Alvarez was raised by working-class parents in the Pilsen neighborhood. (Courtesy Anita Alvarez.)

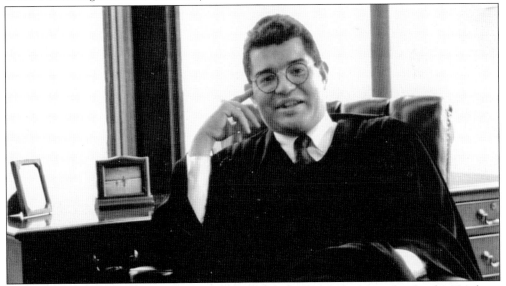

Judge Ruben Castillo (Mexican/Puerto Rican) has served as a district judge for the Northern District of Illinois since 1994. He was formerly a partner in the Chicago office of Kirkland and Ellis. He was also the regional counsel for the Mexican American Legal Defense and Educational Fund. His parents both worked in factories in Chicago for many years. (Courtesy Ruben Castillo.)

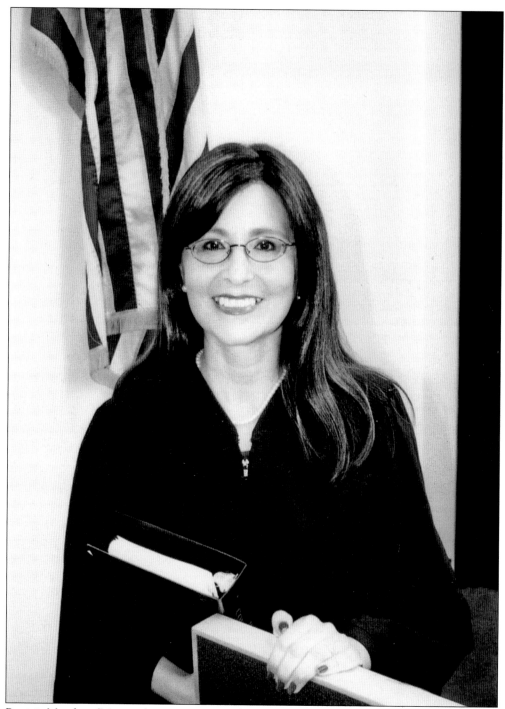

Patricia Mendoza (Mexican) is an associate judge for the Circuit Court of Cook County currently assigned to the Juvenile Justice Division. Previously she was assigned to the First Municipal Division's Traffic Court Section and Domestic Violence Court. She was also the regional counsel for the Mexican American Legal Defense and Educational Fund. There are now 26 Latino federal and state judges in Illinois. (Courtesy Patricia Mendoza.)

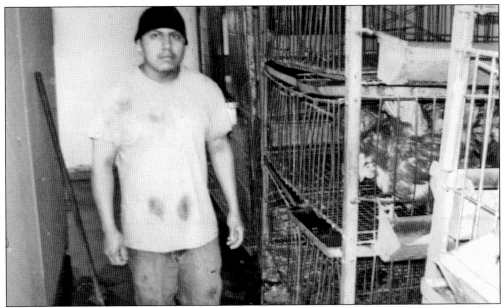

Qascual Vicente (Mexican) works at John's Live Poultry on Chicago's near north side. He kills and prepares rabbits, geese, ducks, roosters, and chickens for customers. The organic poultry comes from Amish farms in Indiana. The owner of the business is Puerto Rican. (Photograph by Wilfredo Cruz.)

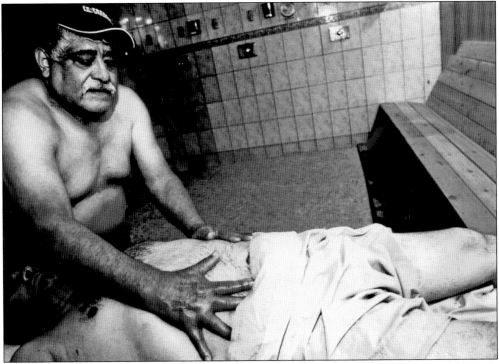

Eddy Anaya (Mexican), a masseur of 35 years at the Division Street Russian and Turkish Baths, give Roger Garcia, a patron of 20 years, a massage in the afternoon. (Courtesy Columbia Chronicle.)

Unidentified Mexican men plant trees and flowers on Chicago's north side. Many Mexican, Guatemalan, and Salvadoran men make a living by working for landscaping companies in Chicago and the suburbs. (Photograph by Wilfredo Cruz.)

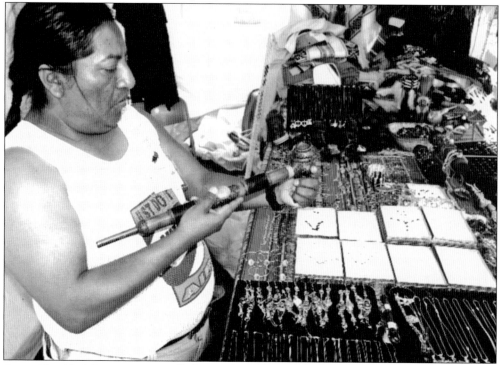

An unidentified Peruvian man sells his products during the 2008 Fiesta Boricua in Humboldt Park. (Photograph by Carlos Soria, courtesy Luis Cabrera.)

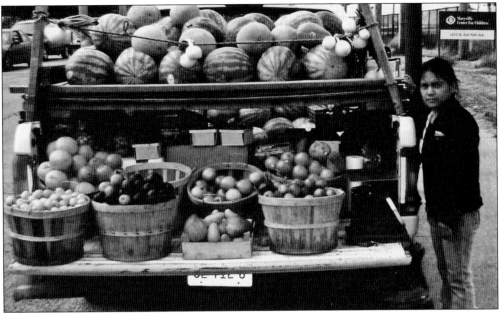

Blanca Gutierrez (Mexican) sells fruit on a street corner from her pickup truck. She has been selling fruit for over eight years. All of her fruit comes from Michigan. Her husband works in construction but is currently unemployed. (Photograph by Wilfredo Cruz.)

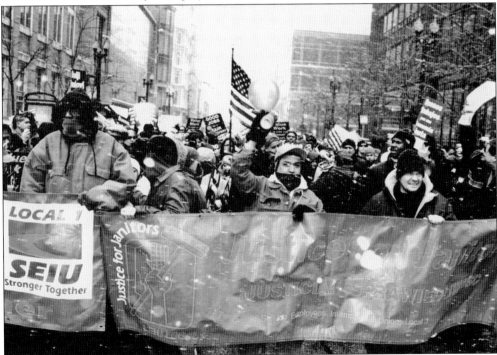

Many of the janitors who clean commercial buildings in Chicago's downtown and suburbs are Latinos. Here hundreds of janitors, many of them African American, white, and Latino, march in downtown Chicago seeking higher wages and a better contract in 2009. (Courtesy Service Employees International Union.)

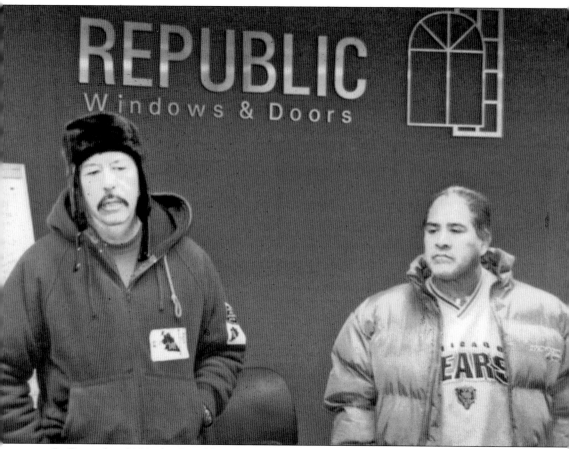

In December 2008, the Republic Windows and Doors Company unexpectedly shut down and fired 250 workers. Many of the workers were Mexican, Puerto Rican, Guatemalan, Salvadoran, white, and African American. The fired workers attracted national attention by conducting a six-day sit-in at the plant until they were paid severance and earned vacation pay. Lalo Muñoz (Mexican, left) worked at the company for 35 years. Juan Salazar (Mexican) worked for 15 years at Republic. (Photograph by Wilfredo Cruz.)

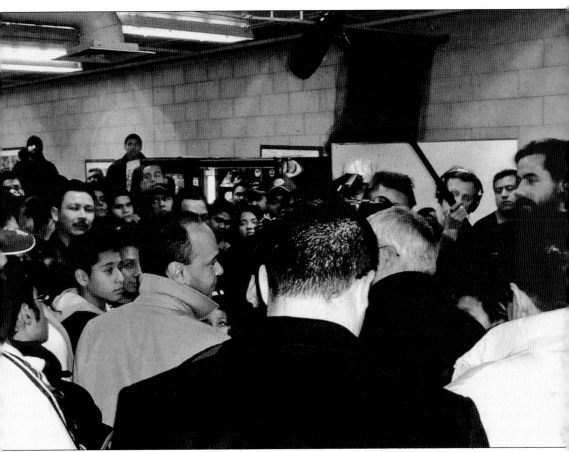

In December 2008, U.S. Congressman Luis Gutierrez (D-Illinois) (Puerto Rican, center) helped draw national attention to the plight of fired workers at Republic Windows and Doors Company. Here, inside the plant, he is meeting with owners of the company and officials of Bank of America. Eventually the workers were paid severance and earned vacation pay. But they did not win their jobs back. Republic was accused of violating labor laws. Prosecutors allege that the company's chief executive officer, Richard Gillman, and two other company officials conspired to loot the business, steal manufacturing equipment, and set up a new nonunion plant in Iowa. Gillman is out of jail on a $500,000 bail. (Courtesy Chicago Workers' Collaborative.)

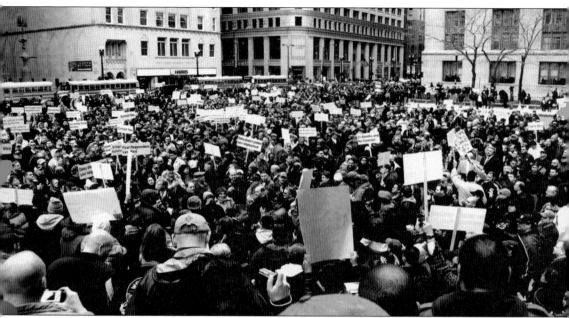

In April 2009, about 3,000 police officers, including African Americans, whites, and Latinos, gathered in Daley Plaza to protest the fact that they were working without a contract. The police were denied a 16.1 percent increase over five years. The protesters shouted "No contract, No Olympics." The event coincided with the International Olympic Committee's visit to review Chicago's bid for the 2016 summer Olympic games. (Photograph by Joseph Camara, courtesy *Columbia Chronicle*.)

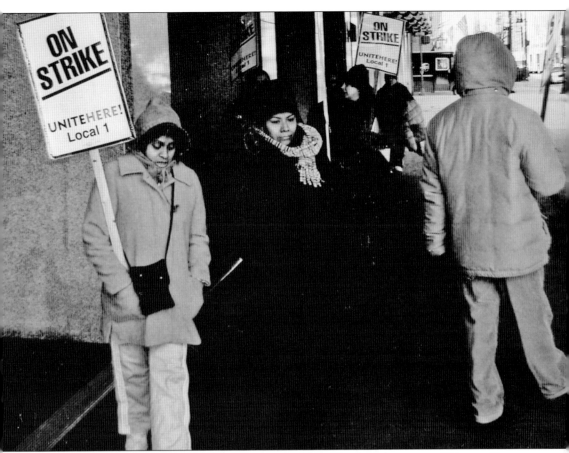

Housekeepers and food workers picket the Congress Plaza Hotel in downtown Chicago. Over 100 workers, many of them Mexican and Guatemalan, walked off their jobs in June 2003 seeking higher pay and better health benefits. The strike has been going on now for six years. It is one of the longest hotel employees strikes in U.S. history. Some of the strikers have found other work, but others continue with the strike. (Photograph by Wilfredo Cruz.)

Hundreds of people gather on Chicago's near north side on Memorial Day 2009. Many of those in attendance were Mexican and Asian Americans. The marchers were defending the right of immigrant workers to work in the United States. They were against the deportation of undocumented workers. (Photograph by Wilfredo Cruz.)

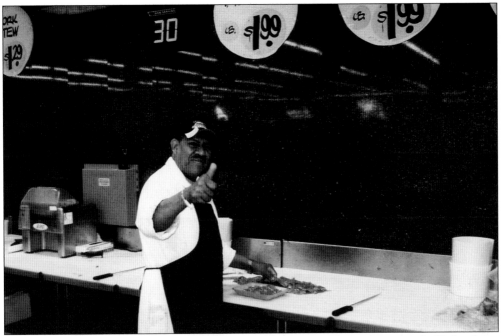

Pedro Toledo (Mexican) is a butcher at the Mayfair Market on Chicago's north side. He has been a butcher for 30 years. (Photograph by Wilfredo Cruz.)

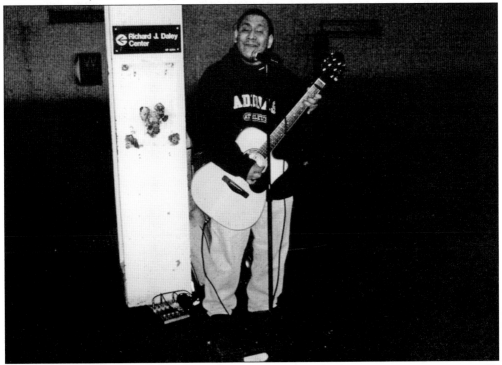

An unidentified Mexican man, who is legally blind, makes his living as a street musician. He plays English and Spanish songs every day in the subway. Many people put money in his cup. (Photograph by Wilfredo Cruz.)

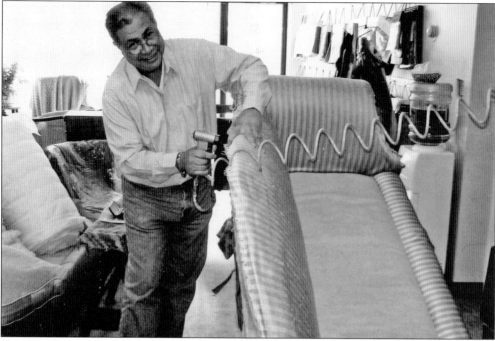

Marcos Alvarez (Mexican) owns a small upholstery shop in the Humboldt Park neighborhood
He repairs furniture, including sofas, chairs, and tables. He has been at his trade for 32 years.
Many of his clients come from the suburbs. (Photograph by Wilfredo Cruz.)

Hugo Ortega (Mexican) has been remodeling homes for over 20 years. He specializes in roofing,
windows, and siding. Here, in 2008, he is replacing a roof and siding on a home on Chicago's
north side. (Photograph by Wilfredo Cruz.)

Hector Hernandez (Mexican) has been the head librarian of the Rudy Lozano library for over 18 years. The library is located in Pilsen. Hernandez started a popular chess club at the library. Many neighborhood children come to the Library to read and play chess. (Courtesy Philip Molotis.)

Sergio R. Gonzales (Mexican) is a tax accountant. He has his business on Chicago's north side. He has been preparing corporate and individual taxes for over 20 years. (Photograph by Wilfredo Cruz.)

www.arcadiapublishing.com

Discover books about the town where you grew up, the cities where your friends and families live, the town where your parents met, or even that retirement spot you've been dreaming about. Our Web site provides history lovers with exclusive deals, advanced notification about new titles, e-mail alerts of author events, and much more.

MADE IN THE USA

Arcadia Publishing, the leading local history publisher in the United States, is committed to making history accessible and meaningful through publishing books that celebrate and preserve the heritage of America's people and places. Consistent with our mission to preserve history on a local level, this book was printed in South Carolina on American-made paper and manufactured entirely in the United States.

This book carries the accredited Forest Stewardship Council (FSC) label and is printed on 100 percent FSC-certified paper. Products carrying the FSC label are independently certified to assure consumers that they come from forests that are managed to meet the social, economic, and ecological needs of present and future generations.

FSC
Mixed Sources
Product group from well-managed
forests and other controlled sources

Cert no. SW-COC-001530
www.fsc.org
© 1996 Forest Stewardship Council

Find Your Place in History.